IMAGES
of America

BALTIMORE'S
LEXINGTON MARKET

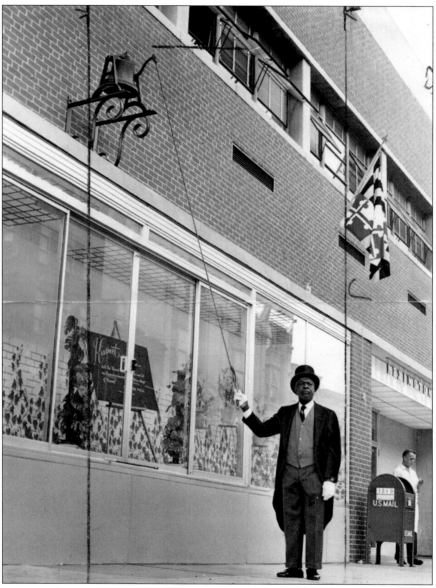

For many years, James B. Carpenter, who ran the market's shoe shine concession, assumed the unofficial position as the market's bell ringer. Every evening, Carpenter would dress in formal attire and ring the old bell, the traditional means of signaling the end of business, dating from the market's founding in the 18th century, when timepieces were rare. The bell currently hanging at the market is a replica, and the tradition has been transformed into one acknowledging important events. On September 11, 2002, Sam Illardo, the market's unofficial historian, rang the bell to honor all those lost in the terrorist attacks the year before. (Courtesy of *Baltimore News American* Photograph Collection, Special Collections, University of Maryland Libraries.)

ON THE COVER: This photograph by A. Aubrey Bodine dates from the late 1930s. A *Sun* papers photographer for 50 years, Bodine was a renowned romantic pictorialist whose mastery of light to elicit subtle shadings was unsurpassed. This view of Lexington Market looks toward the western reaches of Baltimore. (Photograph by A. Aubrey Bodine © Jennifer Bodine.)

IMAGES
of America

BALTIMORE'S
LEXINGTON MARKET

Patricia Schultheis

ARCADIA
PUBLISHING

Copyright © 2007 by Patricia Schultheis
ISBN 978-0-7385-4361-1

Published by Arcadia Publishing
Charleston, South Carolina

Printed in the United States of America

Library of Congress Catalog Card Number: 2006931306

For all general information contact Arcadia Publishing at:
Telephone 843-853-2070
Fax 843-853-0044
E-mail sales@arcadiapublishing.com
For customer service and orders:
Toll-Free 1-888-313-2665

Visit us on the Internet at www.arcadiapublishing.com

To Bill, who taught me that discovering the past is both
a responsibility and an adventure.

CONTENTS

ACKNOWLEDGMENTS

Baltimore's Lexington Market is the result of wonderful generosity, helpfulness, and encouragement from dozens of individuals and institutions. I am deeply indebted to Darlene Hudson of the market's management for her tireless patience, to Jeff Korman of the Enoch Pratt Free Library, to the staff of the Hornbake Library at the University of Maryland, and to the Hearst Corporation. I also wish to thank Ron Kreitner and Anand Bhandari of Baltimore's Westside Renaissance; the Jewish Museum of Maryland; the Baltimore County Public Library; the Baltimore City Archives; the Maryland Historical Society; Ross Kelbaugh of Historic Graphics, LLC; and that wonderful photographer Jack Eisenberg. This project would not have been possible without the enthusiastic support of several stall keepers and the families of former stall keepers who told me their stories and who trusted me with their precious personal photographs. So I say a special thank-you to Gil and Carolyn Barron, Nick Konstant, Bill Devine and the Faidley family, Minas Houvardas, Cynthia McCrory, Michael Papantonakis, Anthony and Marie Serio, Janet Whittle Freedman, Alvin Manger, and Winn Harger. I also want to acknowledge the extraordinary help and technical assistance I received from Jacqueline Greff, author of Arcadia Publishing's *Fell's Point*. Without her know-how, I could not have included much of the market's earliest history. Thank you, too, to John Waters, Gilbert Sandler, and my friend Rosalia Scalia. Finally, of course, thank you to that helpmate, historian, and husband extraordinaire, Bill, who found the sources and stuck with me till the end.

INTRODUCTION

In Baltimore, certain place names represent fixed points in the city's shared civic memory. For 225 years, Lexington Market has been such a landmark, serving as a touchstone to both Baltimore's history and to the personal stories of its families.

Whether it is the day their grandmother bought crab meat when their uncle came home from the war, or the time their mother got strawberry shortcake for their wedding shower, all Baltimoreans, no matter what they achieve or how far they roam, have a Lexington Market story to tell. Even Baltimore native and film writer and director John Waters has a Lexington Market memory: "I always loved the Lexington Market as a kid because all I noticed was the meat and it looked really scary."

A vast, hurly-burly food emporium, the market is a public facility, one of six public markets in Baltimore. The city owns the land and buildings, and a private, nonprofit corporation oversees the market's operations. Individual merchants rent the stalls, a right they can pass along to their children.

Although nowadays buildings obscure the topography, Lexington Market actually sits atop a hill. The street stretching toward it is Lexington Street, named for the first battle in the American Revolution. In 1782, John Eager Howard, a hero in the Revolution, gave a portion of his vast personal estate to establish a market in Baltimore's "western precincts," away from the harbor but easily accessible to Maryland's fertile farms to the west.

Without waiting for a proper market house, farmers set up rude wooden stalls and began selling livestock and produce to the city's growing population. By the time a wooden shed was constructed 20 years later, the market was widely known for its astonishing variety. By the 1850s, every day the market was open, tens of thousands of shoppers came to the market houses and to the stalls spilling out onto nearby streets.

Succeeding waves of immigrants—German butchers, Greek candy makers, Italian produce sellers, Jewish bakers, and delicatessen men—disembarked in Baltimore and found a threshold to the American dream by renting stalls and adding their unique flavor to the market's offerings.

By the 1920s, Lexington Market had three block-long sheds with more than 1,000 outdoor stalls surrounding them. Civic leaders wondered if, with its rough-and-tumble hawker attitude and jumble of outdoor stalls that clogged streets and blocked traffic, Lexington Market was inappropriate for a modern metropolis. Not that Baltimoreans cared. Highborn ladies with their chauffeurs and housewives with trolley tokens in their pockets continued to flock there on Tuesdays, Fridays, and Saturdays—the three days a week the market was open. Fresh buttermilk, beef, mutton, terrapin, canvasback, sausage, strawberries, kale, squash, cheese, and apples of all sorts—if it wasn't at Lexington Market, it wasn't meant for human consumption.

While the city fathers temporized, fate intervened. In the early hours of March 25, 1949, a six-alarm fire destroyed the market's main building. But the market itself would survive. The mayor at that time, Thomas D'Alesandro II, recognized Lexington Market's importance to Baltimore and, within hours of the fire, vowed that it would be rebuilt. Since reopening in 1952, the market

has had two major renovations: an addition in 1982 and a recently completed major update to the West Market complex. Today nine generations of Baltimoreans have shopped at to the market on Howard's Hill.

Coming to Baltimore as a young schoolteacher, I found Lexington Market a remarkable example of American enterprise and ingenuity. Some 40 years later, I still do. When I began this project, I was hoping to capture some of the market's bawdy spirit, as other writers have done so admirably in the past. However, as I probed into the market's history and listened to the stories of its stall keepers, I came to appreciate that the market's enduring place in Baltimore's heart results not from the bravado of its merchants nor from the market's atmosphere of serendipity, but from unremitting hard work and fierce pride. While shoppers may find the market's variety an epicurean's delight, every crab cake, corned beef sandwich, and vanilla cream candy is the product of untold effort and countless hours of work, both by today's stall keepers and those in the past. I sincerely hope I have done them and the market justice.

One

A Hero's Gift

"As good an officer as the world affords" is how Gen. Nathaniel Greene described the young Maryland colonel who served under him during the American Revolution. John Eager Howard was a wealthy landowner whose property included vast expanses of what is now Baltimore City and Baltimore County. He later became a delegate to the Continental Congress, governor of Maryland, a U.S. senator, and leader of the Federalists. In 1782, Howard gave part of his land in the "western precincts" to establish a market, on a site some annals say was a regular venue for wrestling, cockfighting, bear baiting, and horse racing. (Courtesy of Enoch Pratt Free Library, Central Library/State Library Resource Center, Baltimore, Maryland.)

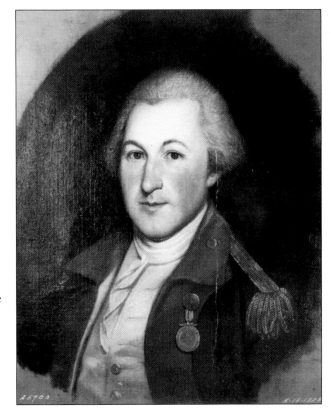

9

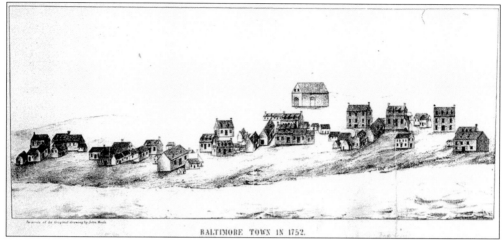

BALTIMORE TOWN IN 1752.

This depiction of Baltimore by John Moale, who owned property on the Middle Branch of the Patapsco River, shows early Baltimore as a scant scattering of structures clinging to the harbor and scarcely prefiguring the metropolis soon to come. It is also notable because of its date, 1752, the year of John Eager Howard's birth. Howard's emergence as a leader of his nation and a man of great means parallels Baltimore's growth as a city. (Courtesy of Enoch Pratt Free Library, Central Library/State Library Resource Center, Baltimore, Maryland.)

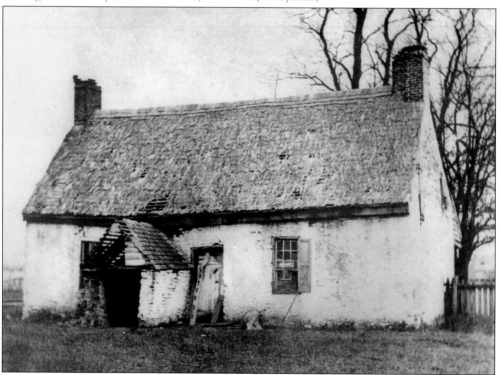

This 1890 photograph shows the home of Joshua Howard, the grandfather of John Eager Howard. An immigrant, Joshua Howard received a large land grant named Howard's Inheritance soon after 1685. The house, near Pikesville, now a suburb of Baltimore, disappeared in the early 1900s, and the property became known as Grey Rock. (Courtesy of Henry R. Evans in the collection of the Enoch Pratt Free Library, Central Library/State Library Resource Center, Baltimore, Maryland.)

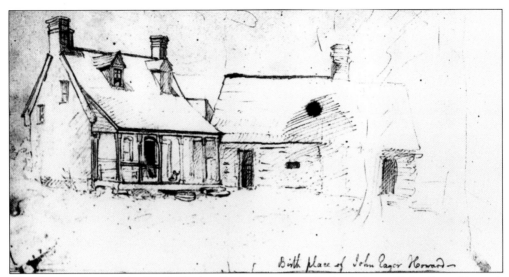

This drawing (c. 1845) by Frank Blackwell Mayer shows of the birthplace of John Eager Howard. Built by his father, Cornelius, the house featured two gables and a log outbuilding and was on Reisterstown Road. Doubtlessly, the farmers traveling that turnpike on their way to their stalls at Lexington Market little realized they were passing the birthplace of the market's founder. The house was demolished in 1857. (Courtesy of Baltimore County Library.)

Not content to simply inherit his father's estate, Cornelius Howard, father of the Revolutionary War hero, sought his own opportunities in the growing town of Baltimore. He married Ruth Eager, whose brother George owned Lunn's Lot, shown just to the left of the north-south axis line on the map. Having given his brother-in-law power of attorney, George went to sea and was never seen again, whereupon Cornelius took control of Lunn's Lot, having it enlarged to include contiguous properties.

11

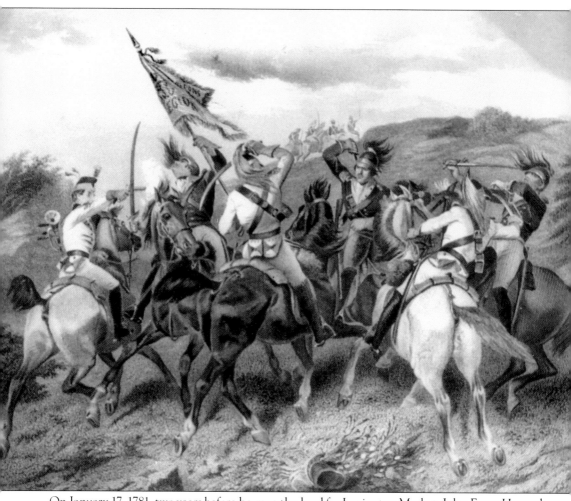

On January 17, 1781, two years before he gave the land for Lexington Market, John Eager Howard was the hero in a decisive battle of the Revolution. Fought near Cowpens, South Carolina, the battle was a critical turning point for the beleaguered army of Gen. Nathaniel Greene. While this picture shows the charge of the cavalry, it was Howard's infantry who carried the day by enticing the British to pursue them in retreat, then turning and firing a withering barrage. Seeing that the British had become very disordered and scattered, Howard next ordered his men to make a bayonet charge. As a result, the Marylanders captured the British artillery, and the battle was over. For his valor, Howard received one of only eight medals given by the U.S. Congress to heroes of the Revolution. (Courtesy of Enoch Pratt Free Library, Central Library/State Library Resource Center, Baltimore, Maryland.)

Kitchen

With his inherited wealth and inherent leadership qualities, John Eager Howard assumed a prominent place in the new country. The contrast between the kitchen of his father's home (above) and Belvedere, the palatial home Howard built for himself in 1786 in Baltimore is indicative of the astonishing growth of the Howards' wealth and influence. Standing on a bluff 20 feet high, Howard's mansion had a garden looking southwest and afforded a grand view of the burgeoning city. Belvedere was later torn down to extend Calvert Street. The drawing of the kitchen (c. 1845) is by Frank Blackwell Mayer. (Above image courtesy of the Baltimore County Library; below image courtesy of the Maryland Historical Society.)

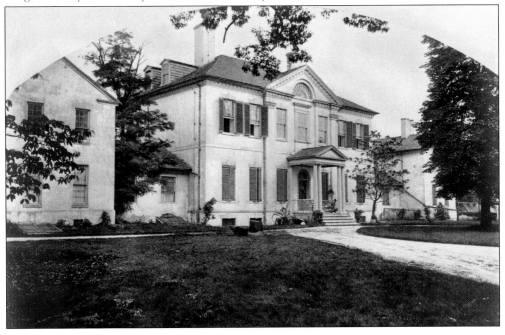

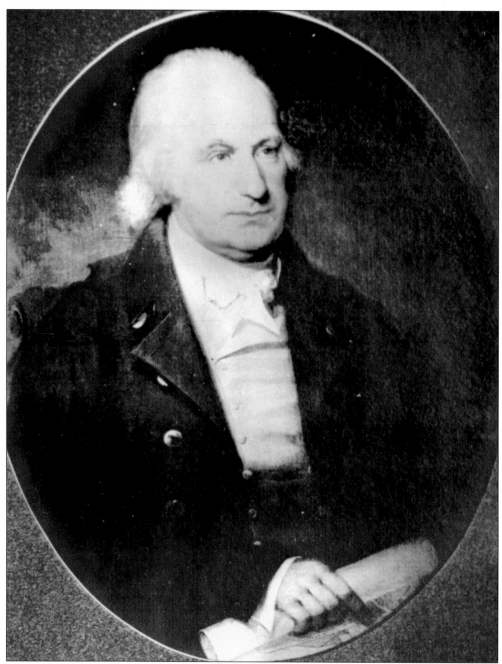

Howard named the street running past the south side of his market Lexington, after the first battle of the Revolution, and eventually the market, which had been referred to as Howard's Hill Market, took on the name of the street and of the battle. The street in front of the principal market house also has the origins of its name in the Revolution, being named after the Battle of Eutaw Springs, South Carolina, where Howard also had fought gallantly. (Painting by Philip Tilyard; photograph from the collection of Dr. and Mrs. Arthur B. Bibbins; courtesy of Enoch Pratt Free Library, Central Library/State Library Resource Center, Baltimore, Maryland.)

Two

A VAST QUANTITY OF PROVISIONS

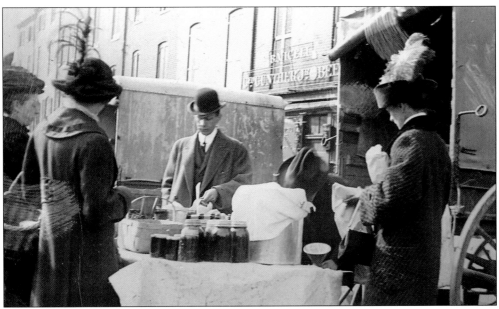

These ladies, in their Edwardian garb, are buying jellies and "smear case," the German term for cottage cheese. Baltimore had a large German population, and smear case would not have sounded unusual. The stall keeper's bowler hat and formal shirt and tie were not unusual either. By the late 19th century, Lexington Market was more than a 100 years old and world famous. The stall keeper's dress reflects the prestige of having a stall there. Unlicensed "hucksters" were prohibited from selling fish or produce on the highways within five blocks of the market, and police were assigned to enforce these regulations. Violators were fined $25. About the time of this picture, sirloin steaks sold for 20¢ a pound and eggs for 26¢ a dozen. (Courtesy of Historic Graphics.com/Ross J. Kelbaugh Collection.)

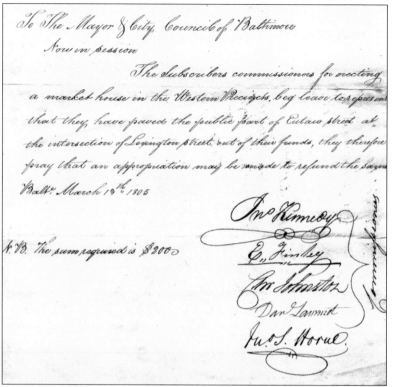

In 1785, the market commissioners appointed Septimus Noel as the market's first clerk. Twenty years later, as this document shows, the commissioners charged with erecting a market house in Baltimore's "western precincts" let the mayor and city council know that they had paved the public part of Eutaw Street at the intersection of Lexington Street for $200.

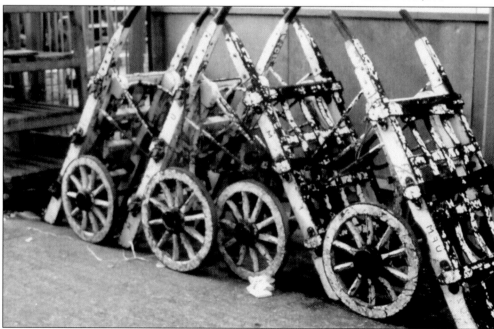

These handcarts were essential in the market's early days, when farmers drove their wagons to the market from distant farms and needed to off-load their products and set up their stalls. In 1822, when Attorney General William Wirt visited the market, he wrote to his daughter remarking on the market's "vast quantity of provisions."

Baltimore August 12, 1818

To The city commisioners Gentlemen I have made in exmination Agreable to yor Advetisement for Proposals to buelding An Adition to The Lexington Market 50 feet in Longth And is wide as the present Market House with 4 Brick pisllars on each Side and 4 posts on each Side with Lime Sont Foot under each post pavement from kerb Ston to kerb Stone As the former House with Good paving Buck each Brick pillar Shall bee well built with Good brick and well Laid with morter shingles of the best quality And All timbers except the Lating And them will be cullings And The same Shall bee Done in Aworkman Like maner For 1400.00 Dollar And Son to the Satisfaction of The city comishioners and be commedced As quick As posible by Mee ___ *Stephen Waters*

To the City comisrs.
 Gentln.

Baltimore August 24th 1818

Last Monday I proposed to build an adetition to Lexington street Market House of fifty feet in the same manner as that already built for The sum of thirteen Hundred and twenty five dollars. I have since examined the house already built and am willing to finish fifty feet in the same manner for the sum of Twelve hundred dollars.

Daniel Cunningham

NB I wish to commence it in the course of this week if posible

DC

By 1818, the market's commissioners, using the name "Lexington," had decided that the market needed to be expanded. These two documents were drawn up in response to an advertisement they had posted requesting bids. In the first, dated August 12, 1818, Stephen Waters proposes to build an addition "50 feet in length and as wide as the present Market House," supported by brick pillars, which would be constructed using "good brick and well laid with mortar shingled of the best quality." Waters's price was $1,500. Twelve days later, Daniel Cunningham makes a counter offer to do just as fine a job for $300 less.

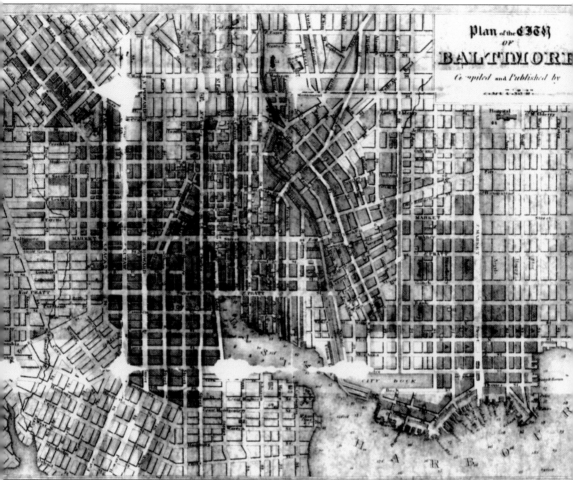

This c. 1827 map, from *A Stranger's Guide to Baltimore*, identifies Lexington Market as a major point of interest in the burgeoning city, a growth that was all the more astonishing when contrasted with the way John Moale depicted the city in 1752. In 75 years, Baltimore had become one of the largest cities in the nation, and its Lexington Market had become known far and wide. (Courtesy of the Maryland Historical Society.)

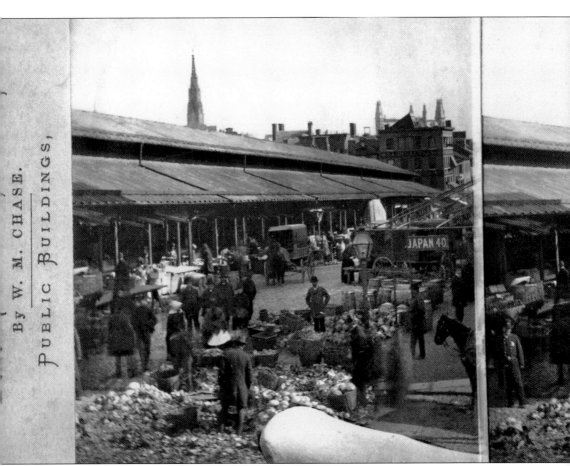

This stereoscopic image from the mid-1800s by William Chase is possibly the first of the market that is not an illustration. Stereoscopic images were taken by a camera with two lenses. When viewed simultaneously through a stereoscope, the two images gave the illusion of three dimensions. Chase had a photographic publishing house on the corner of Lexington and Eutaw Streets, but by the time of this picture, the site had become the studio of David Bachrach, the famed society photographer. The church in the background is St. Alphonsus. (Courtesy of the Maryland Historical Society.)

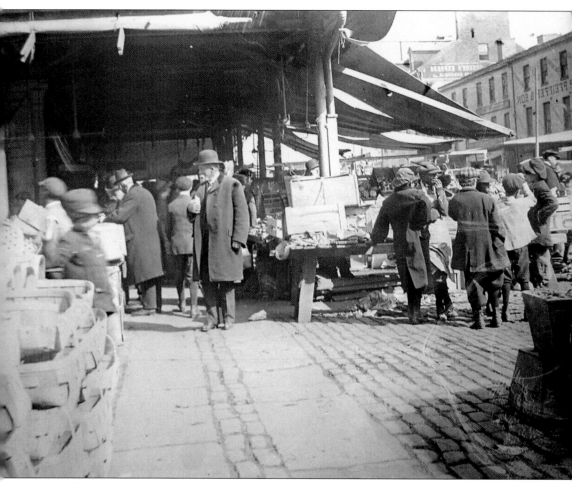

Far from relegating the task of buying the family's weekly food to women, men regularly strolled up and down the market's aisles. Stall keepers were known for their jocularity and badinage, and perhaps it was this give-and-take that men enjoyed. Or perhaps they relished the opportunity to compare prices. About the time this picture was taken, shoppers could find pork chops and rib roasts for 18¢ a pound, potatoes for 40¢ a peck, and 75 shad for $2. The flaps forming the walls of the market sheds are also clearly visible in this picture. (Courtesy of Historic Graphics.com/Ross J. Kelbaugh Collection.)

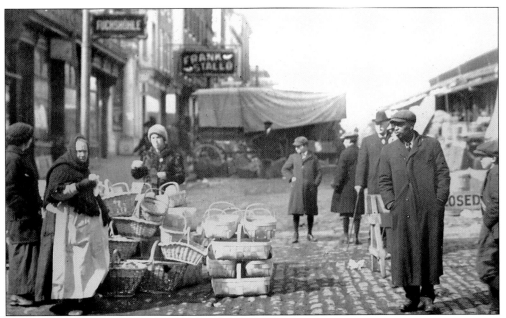

The market commissioners made few exceptions to selling anything but food, and one seems to have been baskets. For many decades, stacks of well-made baskets are seen in photographs, always just south of the market's Eutaw Street entrance. It is believed the baskets were the products of the M. J. Rentz company, which manufactured baskets and willow ware at 60 Orleans Street. (Courtesy of Historic Graphics.com/Ross J. Kelbaugh Collection.)

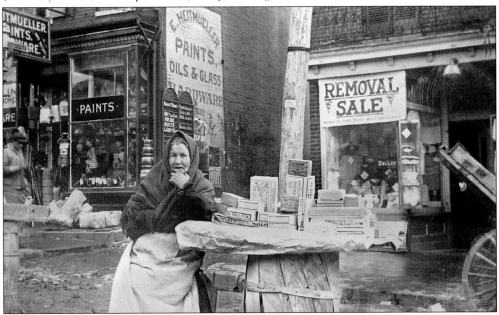

In *Baltimore, a Not Too Serious History*, Letitia Stockett writes about the market and a "dried-up little match woman, no bigger than a child, who would sidle up to you with the cunning of a gypsy, saying, 'Matches, lady?' Woe betide you if you offended her in any way." Perhaps the woman pictured here in this lanternslide is the one Stockett had in mind. (Courtesy of Historic Graphics.com/Ross J. Kelbaugh Collection.)

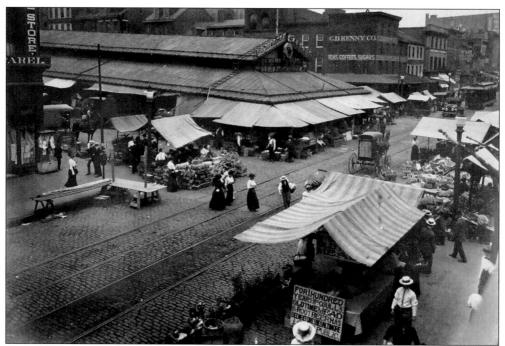

The man in the white shirt and straw boater in the lower right-hand corner of this photograph is walking past a stall with a sign stating, "For a hundred years McCoull's old time mead and root beer." Mead was available at the market well into the 20th century.

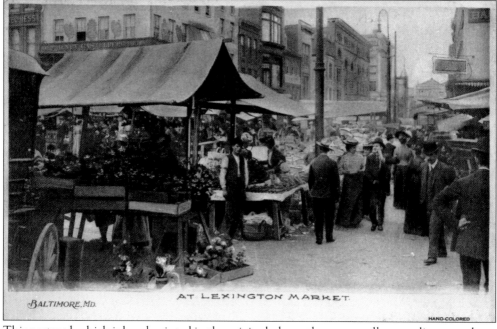

This postcard, which is hand-painted in the original, shows the street stalls extending, down Lexington Street. Just discernable on the left is the building where David Bachrach had his photography studio, but in this postcard, it now bears the name of Henry Castelberg, Baltimore's self-styled "Diamond King." (Courtesy of the Maryland Historical Society.)

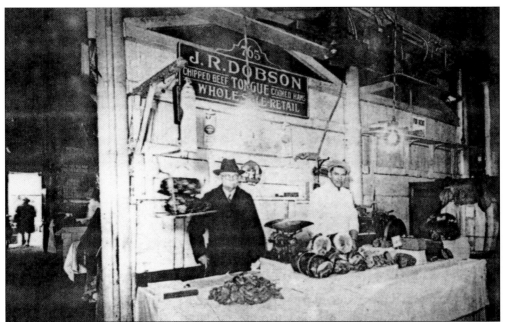

Lexington Market always was primarily a retail market, although, as this postcard clearly shows, some stall keepers did sell wholesale items. Butchers seemed to enjoy an enhanced status within the market's hierarchy and had most of the stalls on the center aisle. They were an extension of the large meatpacking industry in Baltimore, which, in 1900, included nearly 50 establishments that had yearly sales of over $6 million. The doorway onto Lexington Street is on the left in this photograph.

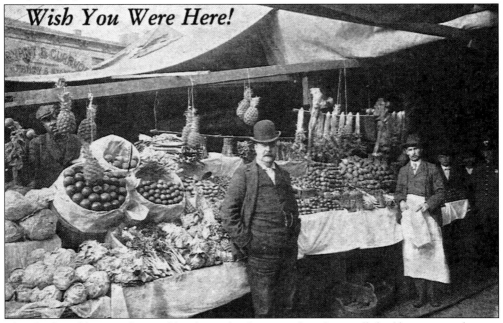

This display of fruits and vegetables shows that keepers of produce stalls had become much more sophisticated in their approach to merchandizing than those in the earlier stereoscopic image. Notice the pineapples, the traditional symbol of hospitality, hanging from the traverse beam.

The colorful flower stalls lining Eutaw Street in front of the market were an arresting sight, and few could resist their colorful displays. Depending on the season, shoppers could choose from a selection of geraniums, violets, chrysanthemums, or white and lavender lilacs, as well as from buckets overflowing with red or yellow roses—veritable jewel boxes in bloom. At Christmastime, the flower stalls featured wreaths, holly, and other greens. Merchants also sold immortelles, wreaths of red straw flowers or wax calla lilies—some in glass-topped cases—that families laid on the graves of their loved ones. Going to the cemetery, like going to the market, was a holiday tradition for Baltimore families. This highborn woman so carefully making her selection was not atypical. Society matrons, some followed by chauffeurs to carry their purchases, mingled with harried housewives. (Courtesy of the Maryland Historical Society.)

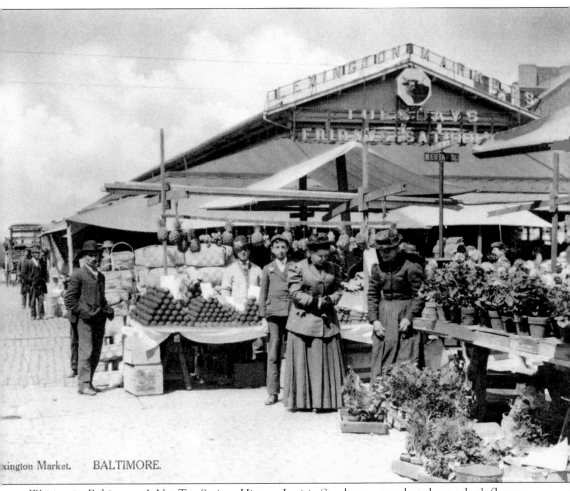

xington Market. BALTIMORE.

Writing in *Baltimore, A Not Too Serious History*, Letitia Stockett notes that the market's flower stalls were especially glorious at Easter: "There are tubs of daffodils, and the hyacinths perfume the air in great waves of lilac, pink, and blue. Bees fly unconcernedly among the traffic, as if the city streets were their lawful preserves. They sally in and out of the hearts of tall lilies, but if the air has a frosty nip, the careful market woman neatly wraps each bloom in oiled paper!" Baltimore is a low-rise city, a style of architecture that gives little privacy but does afford each homeowner a little patch of green, making choosing the right geranium for the pot on the stoop or the right petunias for the back fence all the more critical. (Courtesy of the Maryland Historical Society.)

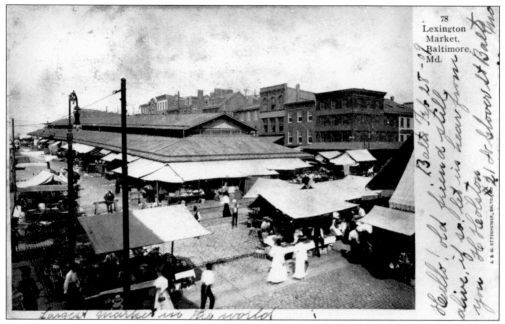

On February 28, 1909, someone named H. Heolston wrote this postcard to an "old friend," asking if the "old friend" were still alive and "if so, let us hear from you." On the bottom, Lexington Market is identified as being the "Largest Market in the World." Note that the streets are still brick. (Courtesy of the Maryland Historical Society.)

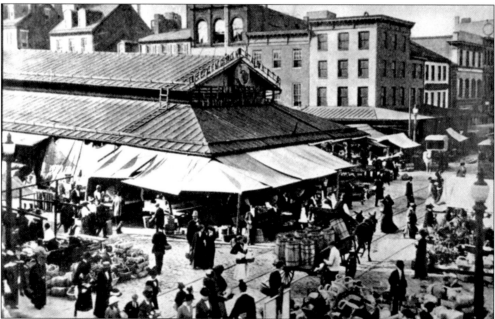

In this picture, as compared with the one above, the market roof has acquired a sign, and the pediment has a medallion of a cow surrounded by fruits and vegetables, which later became the market's icon. In *Baltimore Yesterdays*, Meredith Janvier writes that "long lines of carriages were strung out along Lexington, Paca and Eutaw streets." (Courtesy of Enoch Pratt Free Library, Central Library/State Library Resource Center, Baltimore, Maryland.)

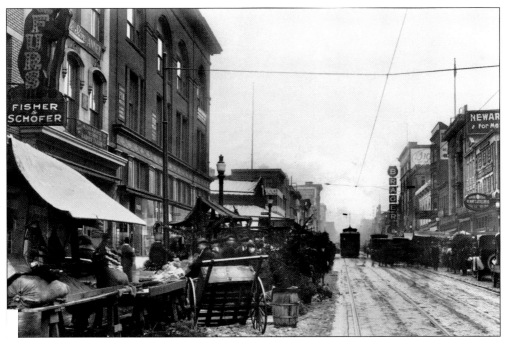

This photograph, taken just south of the market on Eutaw Street, illustrates the harsh conditions that stall keepers worked in, especially those with outside stalls. In rain, snow, or withering heat, they had to put their goods on display and keep their customers happy. The jumble of handcarts, horse-drawn carriages, trolleys, and automobiles shows a society in transition from one mode of transportation to another. (Courtesy of the Maryland Historical Society.)

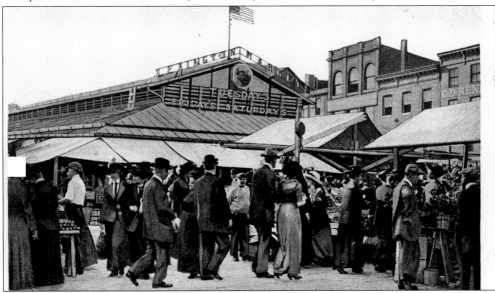

This postcard clearly shows the market's front sign. Lexington Market was and is part of a system of municipal markets, and each originally had assigned days of operation. Lexington Market, as the sign states, was open on Tuesdays, Fridays, and Saturdays, when it was open until midnight. Former stall keeper Gil Barron remembers his father, Daniel, waiting until 11:00 p.m. to sell 22¢ worth of corned beef to the Saturday night crowd leaving a nearby theater. (Courtesy of Gil Barron.)

By enabling the people of Baltimore to buy directly from farmers, without the expense added by a "middleman," Lexington Market was intended to be a source of inexpensive food. Farmers traveled from as far as the outskirts of Washington to have their stalls ready. Long before the market bell rang, farmers spent hours unloading their wagons, arranging their wares, and setting up neat rows of apples and other produce. (Courtesy of Enoch Pratt Free Library, Central Library/ State Library Resource Center, Baltimore, Maryland.)

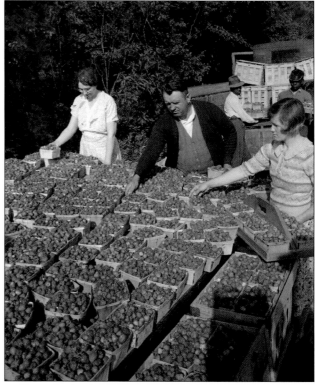

Farming was a hard life, and every basket of strawberries represented hours of labor. Getting fruit at its peak of freshness gave a farmer a competitive edge. Some had permanent stalls in the market's sheds, but many had outside stalls, which had to be taken down and stored the four days the market was closed each week. (Courtesy of Enoch Pratt Free Library, Central Library/ State Library Resource Center, Baltimore, Maryland.)

One reason Lexington Market offered such astonishing variety was that Maryland was a land of abundance, both from the products of its farms and from the Chesapeake Bay, a source of seemingly limitless waterfowl, bass, trout, cod, haddock, eel, perch, sturgeon, pike, and crab. And, of course, there was the bay's crown jewel, the famed Chesapeake oyster, sampled here by a gentlemanly epicure. Bay oyster harvests peaked at 11 million bushels in 1870, and despite cull laws restricting harvesting oysters that are too small and establishing other limits, the harvests have declined steadily ever since. (Courtesy of Enoch Pratt Free Library, Central Library/State Library Resource Center, Baltimore, Maryland.)

Blue crabs remain a Lexington Market staple. This 1883 etching from *Frank Leslie's Illustrated Newspaper* captures the casual spirit of an Eastern Shore crabbing camp. The accompanying article tells how the crabber used a small landing net, "which he deliberately slips under the kicking crab as he hauls in the line, and, with a single turn of the wrist, drops the crustacean into a box lined with the softest seaweed." (Courtesy of Enoch Pratt Free Library, Central Library/State Library Resource Center, Baltimore, Maryland.)

In a 1973 *Sun* article, Ruth Zimmerman Loos recalls her father and brothers, who were farmers like the ones pictured here. "Saturday was a long market day," Loos wrote, "all the more so because the produce had to be hauled into town in a big three-deck, horse-drawn farm wagon. It was close to a three-hour trip each way." (Courtesy of Enoch Pratt Free Library, Central Library/State Library Resource Center, Baltimore, Maryland.)

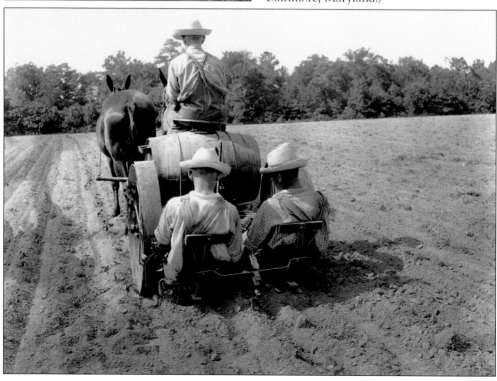

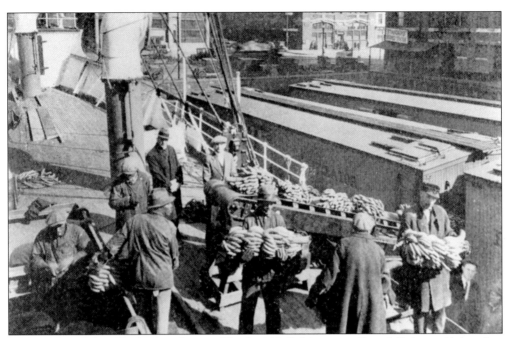

Writing about Johns Hopkins students in *The Amiable Baltimoreans*, Francis Beirne said that they bought "at nearby Lexington Market bananas, right off the banana boats, for only eight cents a dozen." Originally stall keepers were supposed to sell only products raised in Maryland, but commercial pressures were too great, and Maryland farmers had to compete with products from distant locales. (Courtesy of the Baltimore County Public Library.)

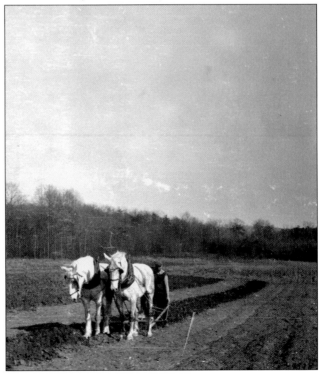

Many of the roads the farmers traveled to get to the market were toll roads with periodic gates that farmers paid to have lifted. The daughter of one gatekeeper recalls, "In summer, when berry season started, the travel on the road was very heavy. At 8:00 p.m. the market people and hucksters in covered wagons started to come through the gate. Market days my father stayed up all night to sell tickets, which the marketeers turned in, then, the next day." (Courtesy of Enoch Pratt Free Library, Central Library/State Library Resource Center, Baltimore, Maryland.)

This picture, taken in the early 1930s, shows the last inn in Baltimore that accommodated farmers as well as their horses. Such facilities were necessary because farmers could not easily "commute" back and forth. This inn primarily served those with stalls in the Bel Air Market, but many such facilities once dotted the streets surrounding Lexington Market. (Courtesy of *The Sun* and Enoch Pratt Free Library, Central Library/State Library Resource Center, Baltimore, Maryland.)

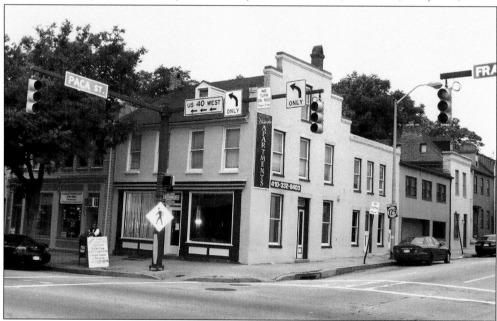

This building on the northwest corner of Paca and Franklin Streets fits the location shown on an early map of inns near Lexington Market. A 1908 guide to Baltimore compiled by the Association of History Teachers of Maryland identifies this building as being the Old Lamb Tavern. (Courtesy of Anand Bhandari and the Westside Renaissance, Inc.)

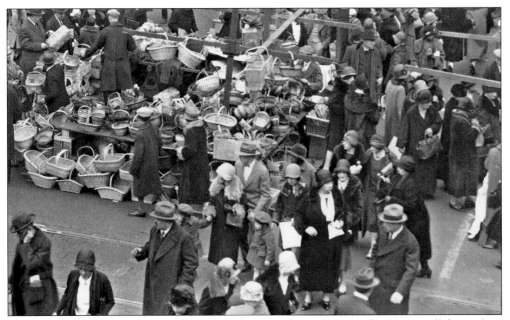

As late as 1926, baskets remained essential, because shoppers going from one stall for veal, to another for coconut, and still to another for jellybeans quickly burdened themselves with many small parcels. Notice, also, the family with two little girls in the foreground. For some children, going to the market was a treat, but for others, it was an opportunity to earn money. (Courtesy of Baltimore News American Photograph Collection, Special Collections, University of Maryland Libraries.)

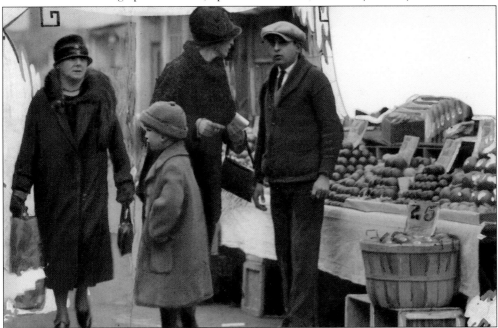

Children frequently worked at their families' stalls. Anthony Serio, whose family had a produce stall, went to work when he was 13. Alvin Manger was 11 when he began working in his family's meat stall. Other children earned a few pennies by carrying packages for customers. (Courtesy of *Baltimore News American* Photograph Collection, Special Collections, University of Maryland Libraries.)

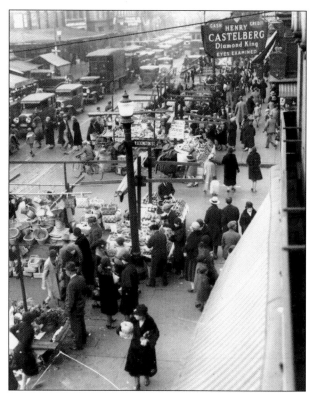

The market became the magnet for other commercial establishments. Jewish tailors established shops that evolved into retail clothing stores. Between the market and the other stores, the entire area near Howard, Lexington, and Eutaw Streets became a consumer's paradise. (Courtesy of *Baltimore News American* Photograph Collection, Special Collections, University of Maryland Libraries.)

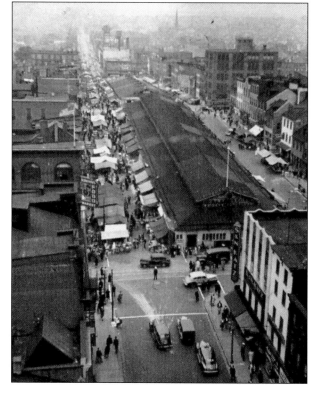

This undated photograph illustrates another reality about the market: even though the streets on both sides were closed on market days, Lexington Street, the one on the left, always attracted the most crowds. Also the problem caused by automobile traffic is becoming apparent in this picture and the one above.

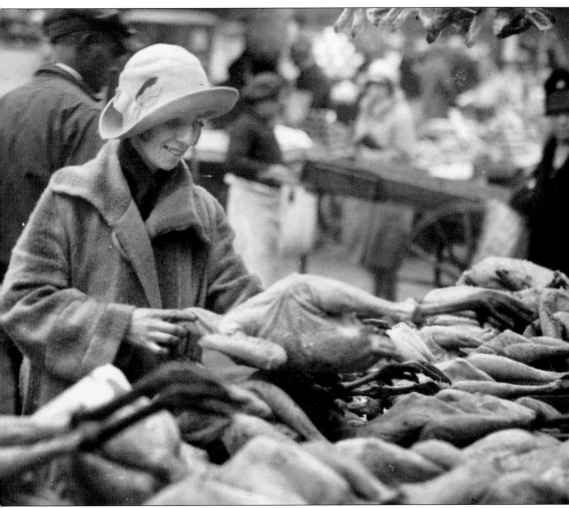

In November 1926, as it was every Thanksgiving, the market was flooded with a throng of customers trying to get the very best provisions for their holiday feasts. This woman, who is choosing a turkey from one of the outdoor stalls, obviously is very pleased with her selection. Holidays were an especially busy time at the market. LuLu Willis, a dietician for the YWCA, calculated that a family of five could have a Thanksgiving feast for less than $7: turkey, eight pounds, live, $4.40; sweet potatoes, 25¢; pumpkin pie, 40¢. (Courtesy of *Baltimore News American* Photograph Collection, Special Collections, University of Maryland Libraries.)

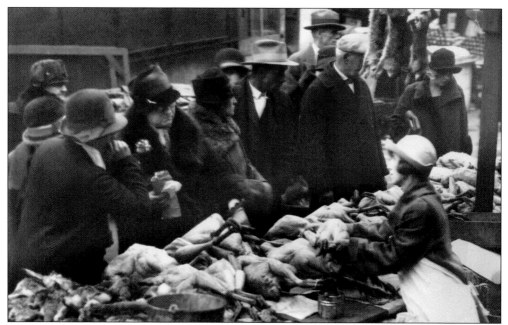

This picture, taken the same Thanksgiving, shows how different the market was from the today's sanitized supermarkets, but still Baltimoreans would not have considered getting their Thanksgiving turkeys anywhere else. Notice the rabbits, or perhaps muskrats, hanging from the post and lying on the boards near the bucket. (Courtesy of *Baltimore News American* Photograph Collection, Special Collections, University of Maryland Libraries.)

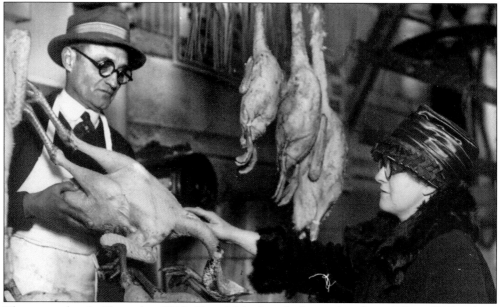

That same day, in November 1926, Clara Mehr bought her turkey from Asbury W. Reedy at one of the market's inside stalls. Mehr also may be in the picture above, looking somewhat dubious about the turkey the stall keeper is displaying, but here she clearly is enormously pleased. (Courtesy of *Baltimore News American* Photograph Collection, Special Collections, University of Maryland Libraries.)

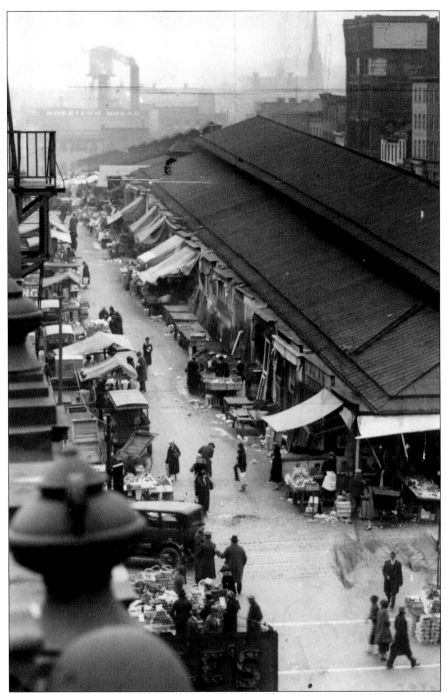

This photograph appears to show the last of the market's three sheds, the fish market between Greene and Pearl Streets. Far in the distance to the west is Koester's Bakery, whose rosy-cheeked, cherubic advertising icon was familiar to many Baltimoreans. Founded in 1887, Koester's was once the largest family-owned bakery in the United States. Also note, on the left, the handcart like the one pictured earlier. (Courtesy of *Baltimore News American* Photograph Collection, Special Collections, University of Maryland Libraries.)

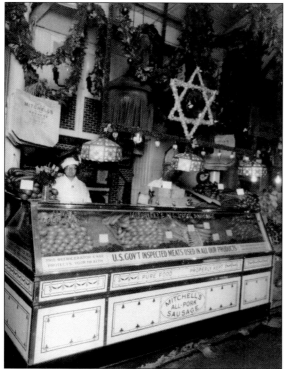

Edna B. Whittle (left) and stall keeper Frank W. Mitchell stand behind the counter of the gleaming Mitchell stall, brightly displaying a Star of David against a backdrop of Christmas decorations. Stall keepers were entrepreneurs and geniuses at salesmanship. Anything that distinguished their stall from the one across the aisle was a plus. (Courtesy of Janet Whittle Freedman.)

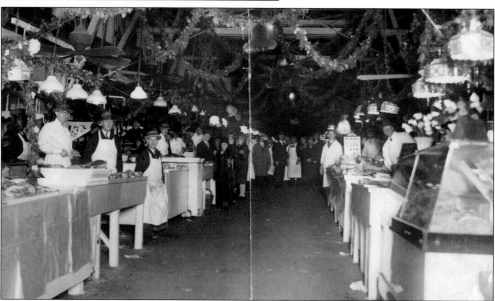

Perhaps Augusta Tucker, the author of *Miss Susie Slagle's*, had this scene in mind when one of her characters, a young medical student, visits the market for the first time on Christmas Eve. Before him, he sees, "Stall after stall, in tightly packed lines, the panorama stretched for three blocks, presided over by people whose ancestors had 'stood in market' before them, whose descendants would stand in market after them, and whose customers remained loyal for generations." (Courtesy of *Baltimore News American* Photograph Collection, Special Collections, University of Maryland Libraries.)

Although none of the market's sheds are visible in this photograph, they are on the left. In *Miss Susie Slagle's*, the young medical student visiting the market for the first time could have been describing this scene when he sees "three and four deep against the buildings, the Christmas trees stood awaiting purchasers." For many Baltimore families, visiting the market was a holiday tradition. This gentleman so carefully making his selection is probably doing what his father, grandfather, and great-grandfather had done every Christmas before him. (Courtesy of the Maryland Historical Society.)

The stalls with awnings to the left of the woman walking up Lexington Street illustrate a point made by Anthony Serio. Even for merchants with inside stalls, the market was hot in the summer and cold in the winter. Also perhaps the large paper bag she is carrying signals the end of the need for baskets.

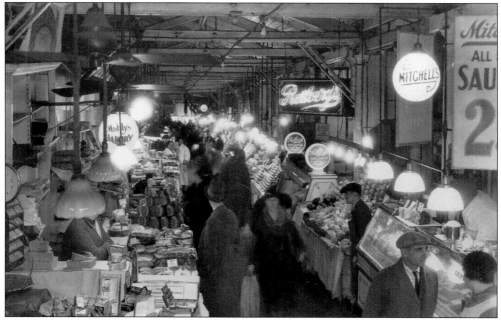

The text by Frederick Stieff accompanying this picture in his *Baltimore Annapolis Sketchbook* says it would be an injustice to attempt to enumerate "this remarkable assemblage of foodstuffs. . . . For we have not the space to list half the vast variety of victuals and viands in view." (Courtesy of Enoch Pratt Free Library, Central Library/State Library Resource Center, Baltimore, Maryland.)

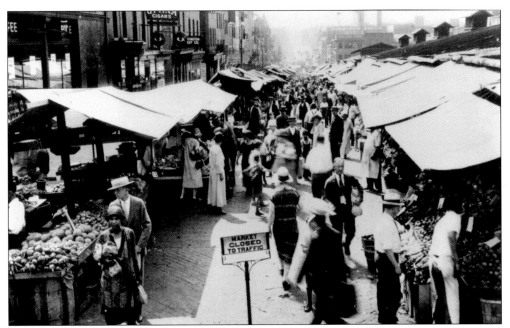

As this sign says, whenever the market was open, Lexington Street was closed to all vehicular traffic. This view looks west, down Lexington Street, which was still brick. Far is the distance, barely discernable, is Koester's Bakery. Judging from the dropped waistlines and cloche hats of the women, this picture is from the late 1920s or early 1930s.

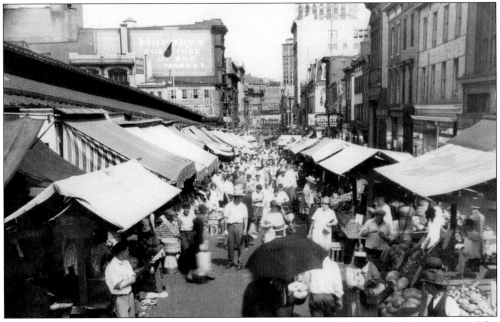

This picture looks in the other direction, east, toward Howard Street, which was named for the market's founder. Eventually the retail clothing stores near the market became full-scale department stores devoted to personal service. Few Baltimoreans of a certain age can't recite the names of the four "grand ladies" on the corners of Howard and Lexington Streets: Stewart's, Hecht's, Hochschild Kohn, and Hutzler's. (Courtesy of the Maryland Historical Society.)

41

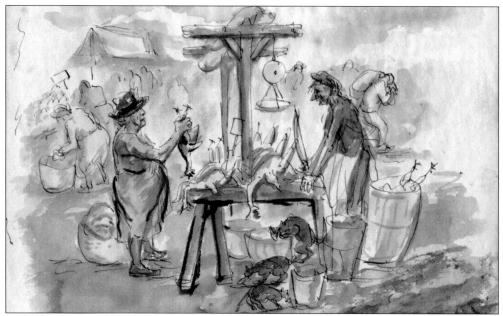

"There is universal meaning in people going after food," Baltimore artist Aaron Sopher once told an interviewer. His drawing of poultry sellers expresses the spontaneity that characterized the market, a quality also evident in Sopher's own work. He almost always drew on-site, and the immediacy of his drawings is often shaded with humor. (Untitled watercolor by Aaron Sopher; courtesy of the Jewish Museum of Maryland, 1996.001.002.)

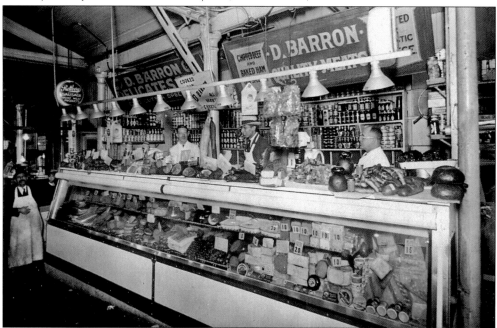

Pictured from left to right are John Jeppi, Lou Reuwer, Wally ?, and Daniel Barron, the proprietor. Gil Barron, Daniel's son, said, "Everything I know, I learned at Lexington Market. Italians, Jews, Russians, Greeks, Germans, they all got along there. They competed, but they got along." (Courtesy of Gil Barron.)

Three

A COLLISION COURSE

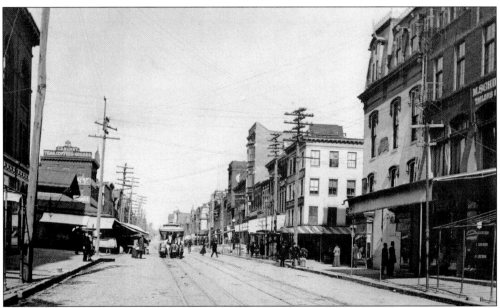

At the end of the 19th century, several issues were creating conflict between the market and the city fathers. Among them was the issue of precisely who owned the stalls. Some stall keepers maintained that their great-grandfathers had won theirs in a lottery when Howard established the market, and that they could sublet and charge as much as they pleased for their stall. The city maintained that it owned the stalls and that merchants only had the right to renew their lease from year to year, much as some families pay for prestigious pews in church. Stalls in the streets compounded the issue. They were supposed to be licensed, but their sheer number made regulation impossible. These stalls also created another difficulty: As Baltimore grew, the congestion was impacting other businesses. In this 1893 photograph, taken on a Sunday afternoon, a horse-drawn car of the Baltimore City Passenger Railway easily passes Lexington Market, just to the left, demonstrating that Eutaw Street, without the market's clutter, functioned as an efficient north-south thoroughfare. (Courtesy of Enoch Pratt Free Library, Central Library/State Library Resource Center, Baltimore, Maryland.)

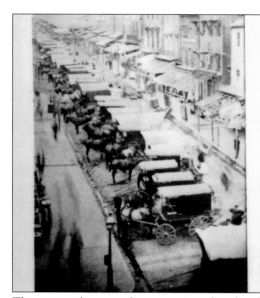

The contrast between the congestion of market days and the easy accessibility to nearby buildings on non-market days is obvious in this photograph. In addition to congestion, accidents were a problem. Farmers staying overnight before market days sometimes left their wagons at the curbs with their shafts projecting over the curbs. A local newspaper reported that "An elderly gentleman, residing in West Lexington Street, while passing home, fell over the tongue of one (wagon) and broke his arm, and otherwise injured himself, and an elderly lady also fell from the same cause."

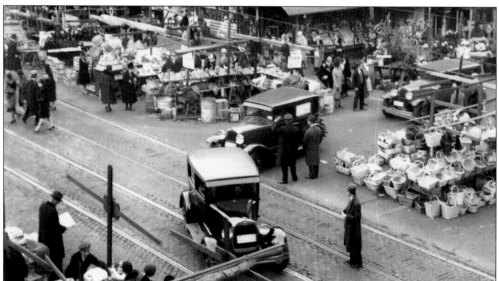

In 1919, retail merchants on Lexington Street complained to Mayor James H. Preston that the proliferation of street stalls was hurting their businesses, especially during holiday time. The stalls, they said, prevented customers from getting into their stores and made deliveries very difficult. In response, the mayor and the board of estimates met and declared that "the sidewalks and bed of Lexington Street would be kept clear of all obstructions." Despite the board's declaration, the street stalls continued. (Courtesy of *Baltimore News American* Photograph Collection, Special Collections, University of Maryland Libraries.)

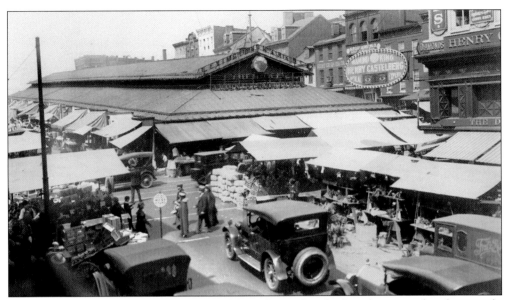

The bull, the market's symbol, is clearly visible in the market shed's pediment in this photograph, which also shows how the street stalls spread into roadbeds, making turning either north or south onto Eutaw Street nearly impossible. The Castelberg sign is still visible on the right in this 1926 photograph. Castelberg had his jewelry store across from the market for 50 years before he sold it in May 1930. (Courtesy of Enoch Pratt Free Library, Central Library/State Library Resource Center, Baltimore, Maryland.)

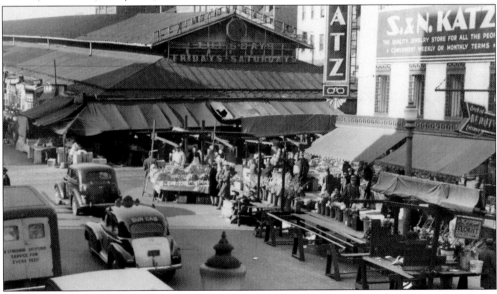

The "S.&N. Katz" sign of the former Castelberg building dates this picture to sometime in the 1930s or 1940s. Taken from the same angle, it shows that little has changed in relation to the street stalls. Litter and refuse disposal also was becoming an issue. "Our department carries to the dump enough boxes and barrels to keep every home in Baltimore warm this winter if not another lump of coal is minded," declared Edward. F. Callahan, deputy commissioner of street cleaning, in 1922. (Courtesy of *Baltimore News American* Photograph Collection, Special Collections, University of Maryland Libraries.)

The market always maintained its appeal, but there is no denying it created a sanitation problem. "Its sanitary condition is behind the times," one letter writer wrote to *The Sun*. Compounding the sanitation problem were nearby stores, which combined their refuse with the market's.

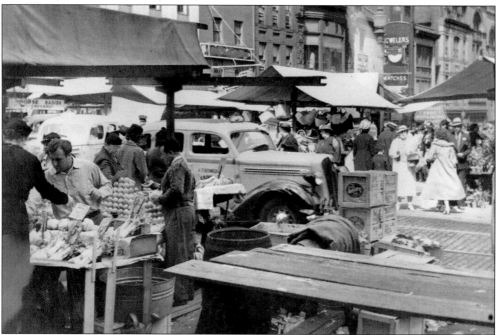

The market was always a delightful distraction from worries, whether big or small. On this May 6, 1937, morning, high-heeled shoppers appear oblivious to the troubles of the Depression and war tensions mounting in Europe. Two days later, the *Hindenberg* would attempt its fateful landing in New Jersey. (Courtesy of the Enoch Pratt Free Library and *The Sun*.)

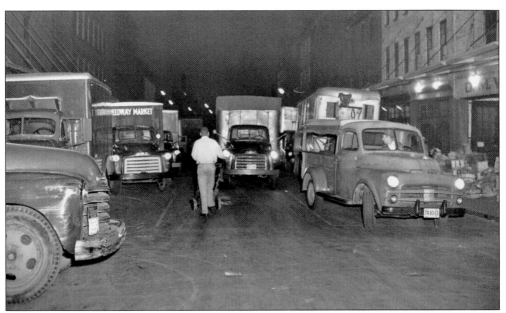

As the era of farmers, with their horse-drawn wagons, was ending, the purpose of the street stalls was no longer obvious. Helping Maryland farmers get their products onto Baltimore tables without a middleman adding to the expense had been John Eager Howard's intention when he gave the land for the market. But with better transportation and warehouses, the middleman was unavoidable. Anthony Serio, whose family had inside and outside produce stalls, remembers his brother Salvatore taking a horse and wagon to a warehouse near Pratt and Light Streets to get chard, spinach, collard greens, turnips, leeks, black-eyed peas, and, at Christmas, chestnuts. These skids of produce and trucks were in front of warehouses only a few blocks from the market, and all the stall keepers took advantage of a distribution system that made products from Florida to Maine available. (Courtesy of *Baltimore News American* Photograph Collection, Special Collections, University of Maryland Libraries.)

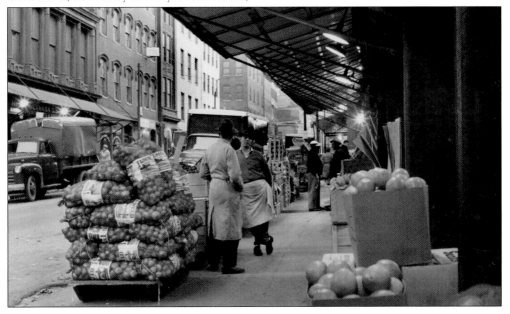

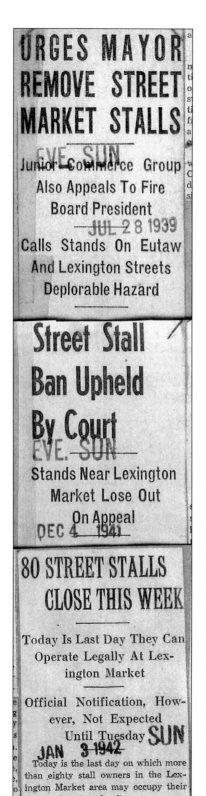

The issue of the street stalls had been a concern since the early 1900s, but by the 1940s, it had become clear that some action had to be taken. In July 1939, the Junior Association of Commerce appealed to Mayor Howard W. Jackson to remove them, calling the stalls "both a traffic and fire hazard which is unquestionably of a deplorable nature." That letter achieved what numerous reports and committees had not: a firm resolve in the form of an ordinance to remove the stalls once and for all. The stall keepers hired an attorney and fought every step of the process, but the city fathers were relentless. In June 1941, the circuit court held that the ordinance was constitutional. The stall keepers appealed to a higher court, but on December 4, 1941, the Maryland Court of Appeals again upheld the validity of the ordinance. By then, the number of street stalls had dwindled considerably. At the time of the ordinance, there were about 80 merchants who sold flowers, fruits, vegetables, and baskets from street stalls. Although the city offered them outdoor spaces on the north side of the sheds, the places were among the least attractive surrounding the market, and few took them. (Courtesy of the Enoch Pratt Free Library and *The Sun*.)

Four

DISASTER BEFORE DAWN

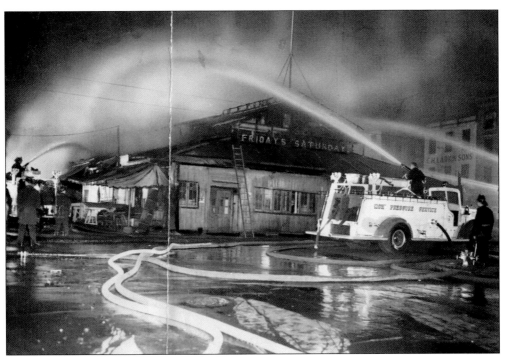

At 3:30 on the morning of March 25, 1949, William Bayne and Charles Green were carrying 100 pounds of ice into the market when they spotted a sudden flare. Opening a stall door, they were met by a wall of flames. Bayne ran to an alarm box, but the flames had already leapt along the natural air duct created by the old wooden roof. Twenty-four engine companies, six truck companies, two high-pressure units, a water tower, and six ambulances responded. Windows in neighboring buildings cracked, and in the nearby Volunteers of America Hospital, new mothers were readied for evacuation, but the firemen managed to contain the blaze to the one shed between Paca and Eutaw Streets. By 4:30 a.m., it was over, and 146 years of history was gone. (Courtesy of *Baltimore News American* Photograph Collection, Special Collections, University of Maryland Libraries.)

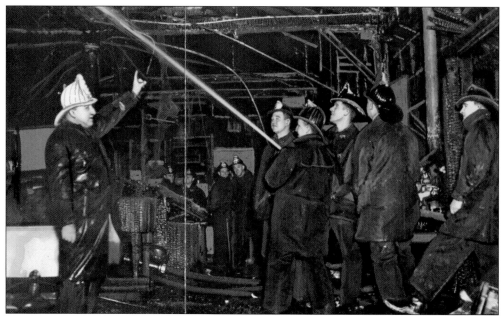

Stall keepers wandered through the rubble, but nothing was salvageable. Porcelain counter tops lay cracked like great white jigsaw puzzles. Weighing scales were warped. And the glass fronts of refrigerated display cases had blown out. (Courtesy of *Baltimore News American* Photograph Collection, Special Collections, University of Maryland Libraries.)

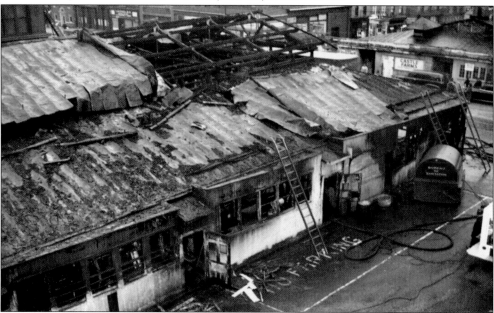

The estimated loss for the building, its 186 stalls, and their contents was $5 million. The fire was especially calamitous because it happened on a Friday morning, when many stall keepers had laid in supplies for the weekend. Fewer than five percent had insurance, ironically because insurance firms considered the building a fire hazard. But by the next night, the Lexington Market Dealers Association had met and was deciding on a course of action. (Courtesy of *Baltimore News American* Photograph Collection, Special Collections, University of Maryland Libraries.)

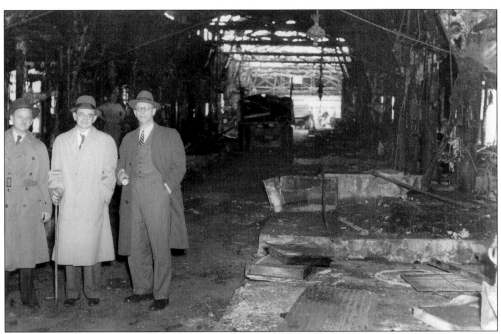

These pictures from the Baltimore health department show the extent of the damage. Stripped to its bare skeleton, the old building's inherent weaknesses also are apparent. The jury-rigged electrical system, poor ventilation, haphazard refrigeration, and casual sanitation all were issues that had plagued the market for years. There also was a serious rodent-control problem. A new market had been on the drawing boards for more than 10 years, and the fire provided the impetus. Sentimentality had been the single largest deterrent to a new market, but sentiments alone could not re-create the old market. A new market was the only option. (Courtesy of Enoch Pratt Free Library, Central Library/State Library Resource Center, Baltimore, Maryland.)

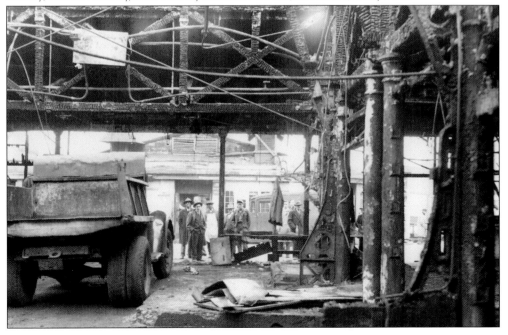

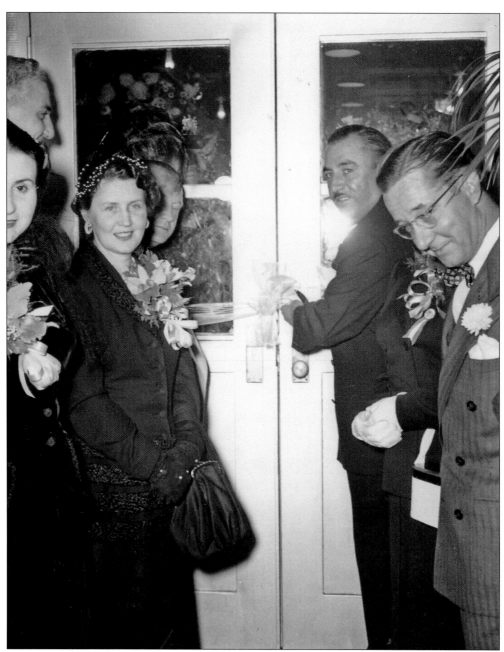

Before the flames died, Mayor Thomas D'Alesandro II visited the scene, went to city hall, and declared, "We will rebuild the Lexington Market." At a meeting of the Lexington Market Dealers Association the day after the fire, City Solicitor Thomas N. Biddison, acting as the mayor's representative, reiterated that the "city was eager to do anything feasible to provide temporary relief pending new construction." Six months and two days after the blaze, on a drizzly September morning, the mayor cut the ribbon to the market's temporary quarters, an aluminum Quonset hut. Business was "perfect," delicatessen owner Mary Mervis declared. "I've been around here 25 years and this is the best crowd I've ever seen," said Mary Lou Bernhardt, a snack-bar owner. (Courtesy of the Baltimore County Public Library.)

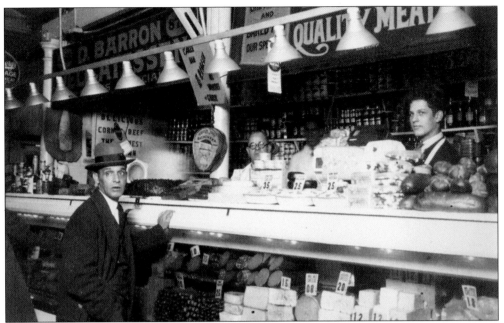

On the morning of the fire, Gil Barron (right, behind the counter with his father, Daniel) was driving toward Baltimore from the University of Maryland in College Park, where he had taken an exam. He remembers seeing the smoke the closer he got to downtown and then seeing the fire trucks. "It was horrible," he recalls. "The market was all my parents knew. It was part of their life." (Courtesy of Gil Barron.)

Many stall keepers received baskets of flowers from customers as testimonials of their loyalty. Raymond Jerns, whose meat stall in the temporary market is shown in this photograph, had been a Lexington Market merchant for 22 years on the night of the fire. (Courtesy of the Baltimore County Public Library.)

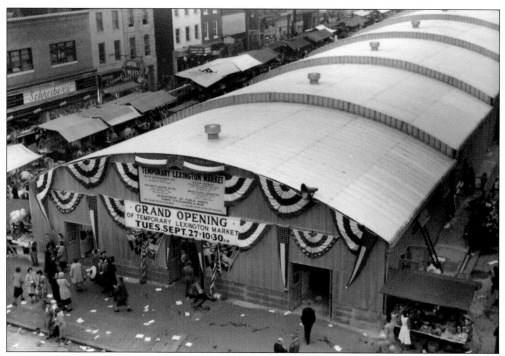

Like the shed it replaced, the Quonset hut had some 180 stalls. It, along with the shed between Paca and Green Streets, which had not been burnt, worked well as temporary quarters. Also, as the top picture illustrates, the outside stalls were operating again. But once the bunting was gone and the initial enthusiasm for having the market back in any form wore off, the Quonset hut was dreary, offering Baltimoreans neither the hurly-burly huckster attitude of the old market nor the convenience and innovations of the one on the drawing boards. (Above photograph courtesy of the Baltimore County Public Library; below photograph courtesy of Gil Barron.)

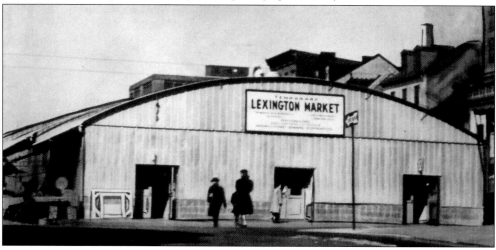

Five

FROM ASHES TO ADDITIONS

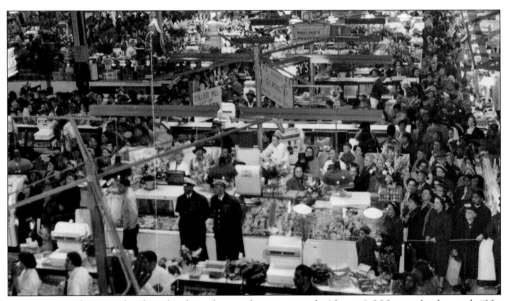

Two years and a month after the fire, the market reopened. About 8,000 people shouted, "Hi, Tommy," as Mayor Thomas D'Alesandro II followed a brass band playing "The Washington Post March" up the center aisle. On the mayor's arms were two young models dressed in bonnets and hoop skirts. Asked about her costume, Lonnie Guzman said it was "supposed to be Colonial." Before an eager crowd, the mayor declared, "Today we are witnessing the formal dedication of a bigger and better Lexington Market, rising Phoenix-like from the ashes of the old landmark that added so much to the charm of Baltimore in a bygone era when life moved at a leisurely pace and good living and hospitality were an essential part of our existence. We shall retain our hospitality, but the tempo has stepped up." (Courtesy of *Baltimore News American* Photograph Collection, Special Collections, University of Maryland Libraries.)

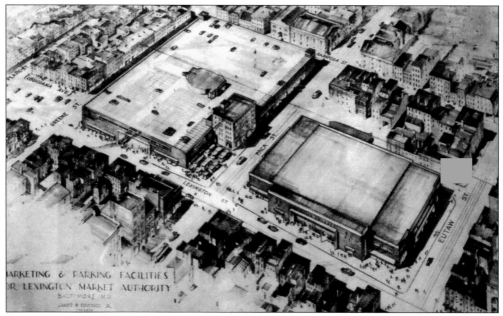

A week after the fire and anticipating having the new market completed within a year, the Lexington Market Authority issued a call for bids. But the process required the acquisition of nearly 100 nearby properties for a garage, something the market sorely needed. The grand reopening was only for the West Market. The East Market's roof still had to be extended, and the Quonset hut had to be demolished.

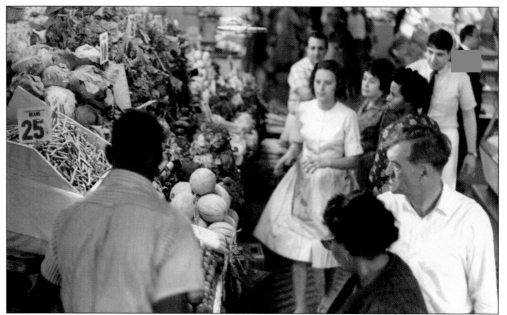

Sentimentalists who feared that the new market would be sterile and lack those idiosyncrasies so dear to Baltimore's palate soon had their worries allayed. In the new market, they found the same pickle sellers, the same taffy makers, and the same fresh-ground coconut they had loved in the old one. (Courtesy of *Baltimore News American* Photograph Collection, Special Collections, University of Maryland Libraries.)

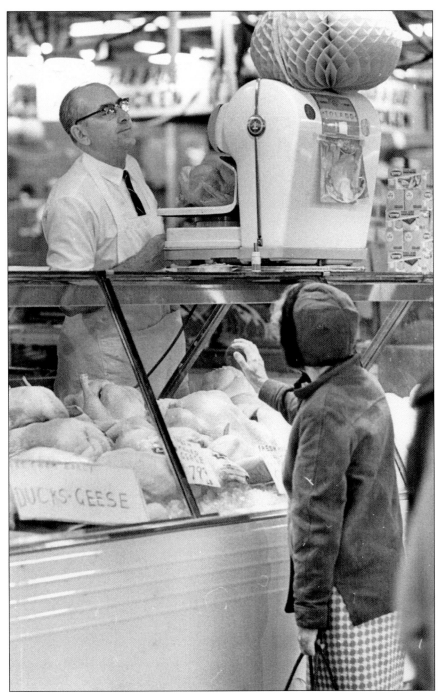

Continuing the tradition of dressing in a formal style, which began when market butchers wore top hats, stall keepers in the 1950s and 1960s wore ties and button-down shirts. In addition to buying a turkey for Thanksgiving, this shopper at the R. J. Sellman stall had the option of buying a fresh-killed goose or duck. Richard Sellman, pictured here, began working in the market when he was a boy. (Courtesy of Enoch Pratt Free Library, Central Library/State Library Resource Center, Baltimore, Maryland.)

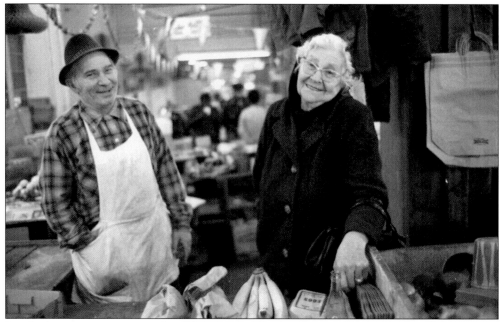

Loyalty between customers and stall keepers was the foundation of the market's success. Trust in the best service at the best price was as much a commodity as a bunch of bananas or a pound of apples. Because stall keepers often competed with the ones across the aisle, personal courtesies sometimes made the difference in having a customer return week after week. (Courtesy of Jack Eisenberg.)

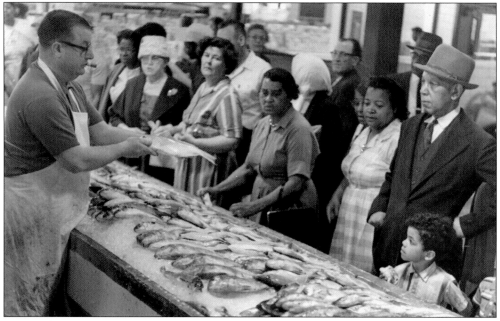

John Faidley, shown here with his characteristic cigar, began working as a boy in the Lexington Market stall of his father, John W. Faidley Sr. From that single location, the Faidley seafood business has grown to encompass the entire corner of the East Market. (Courtesy of *Baltimore News American* Photograph Collection, Special Collections, University of Maryland Libraries.)

A keen observer of domestic life once wrote, "Keeping house is one the few businesses done in a fluctuating market on a fixed sum." The market enabled housewives to buy onions from the stall keeper whose produce was a few cents cheaper than the fellow's across the aisle. She could then take the pennies saved and perhaps buy a better grade of pork chops. (Courtesy of *Baltimore News American* Photograph Collection, Special Collections, University of Maryland Libraries.)

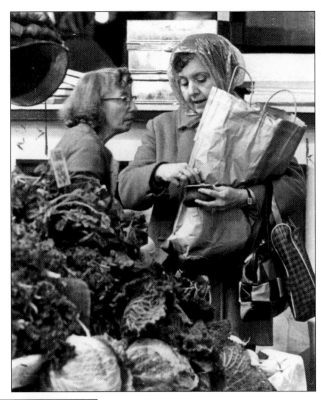

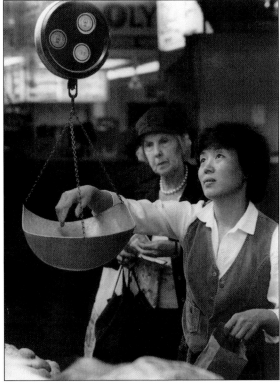

In this 1982 photograph, this shopper with her choker of pearls appears no less concerned with getting maximum value than the woman above in her plastic rain bonnet. Gene Sook Kim, owner of Kim's Produce, makes certain that the customer gets exactly what she wants. (Courtesy of *Baltimore News American* Photograph Collection, Special Collections, University of Maryland Libraries.)

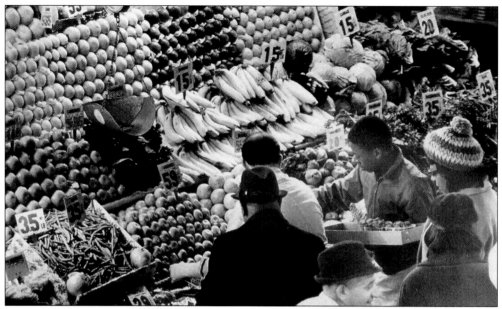

The young man is setting out pints of strawberries. Like opening day for the Orioles, Marylanders know spring has come when they can buy strawberries from local farms. The knitted cap on the woman to the right suggests that this picture is from the 1970s.

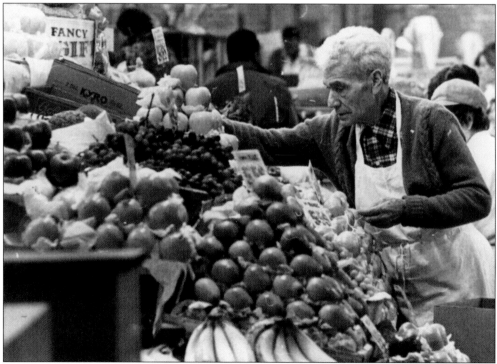

The care with which this stall keeper is arranging his display is proof that neither the market's standards nor the devotion of its stall keepers were diminished when the new, cleaner, fully enclosed facility opened. (Courtesy of *Baltimore News American* Photograph Collection, Special Collections, University of Maryland Libraries.)

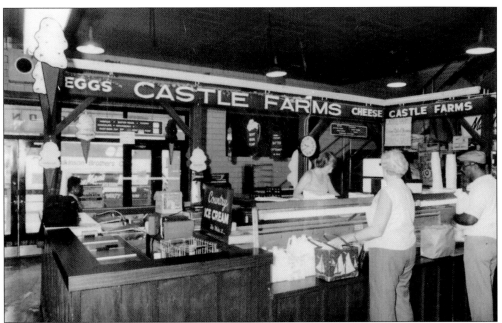

In 1985, an era came to an end at the market when Castle Farms, one of the last farmer-run stalls, closed. The stall was owned by Florence Hillegass Ganong Landis, who sold diary products from her two Carroll County farms, which she also decided to sell. Castle Farms offered cottage cheese with a choice of three curd sizes, unsalted sweet butter, and buttermilk, but it is especially remembered for its ice cream. Made with eggs and from a recipe belonging to Landis's grandmother, Castle Farms's ice cream had a butterfat content of 22 percent, as opposed to 14 percent in most commercial ice creams. In the lower photograph, Samantha Garbis serves a customer a cone on the last day the stall operated. (Below photograph courtesy of *Baltimore News American* Photograph Collection, Special Collections, University of Maryland Libraries.)

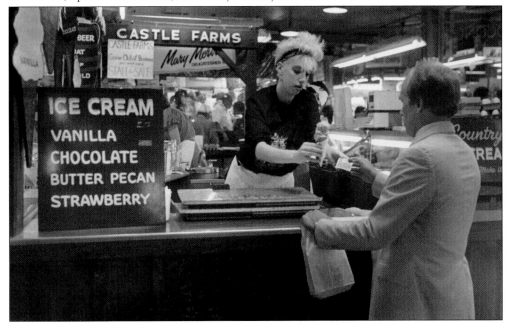

Here a member of the Serio family weighs a package. The market once had two families named Serio—one in the East Market, one in the West Market—and each maintained that they were unrelated to the other. Notice how the corn has been stripped of its leaves so customers could judge the size and color of the kernels. (Courtesy of *Baltimore News American* Photograph Collection, Special Collections, University of Maryland Libraries.)

When Augusta Tucker, the author of *Miss Susie Slagle's*, visited the new market soon after it opened, she remarked on how the "late afternoon sun streaming in on the snow-white cauliflowers, purple eggplant, chalky celery and bright red tomatoes made a tableau." Perhaps she had a scene like this in mind.

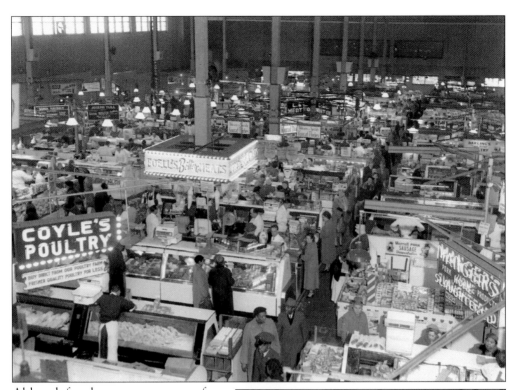

Although few shoppers were aware of it, the new market was such a success because of something under their feet. Beneath the new East Market was a vast system of individual storage and cooking units, each corresponding to a stall above. It was in this underground warren that stall keepers cooked their own corned beef and made their own cole slaw, their own peanut brittle, their own rye bread and fresh-roasted turkeys. Long before dawn, stall keepers were below their stalls preparing their products. The individual merchant's skill in applying seasonings and cooking techniques distinguished his stall's merchandise from the next one's, making variety as well as good prices factors in the competition equation. (Above photograph courtesy of Enoch Pratt Free Library, Central Library/State Library Resource Center, Baltimore, Maryland; bottom photograph courtesy of *Baltimore News American* Photograph Collection, Special Collections, University of Maryland Libraries.)

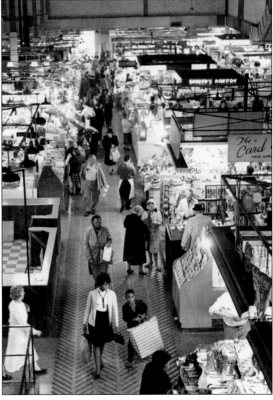

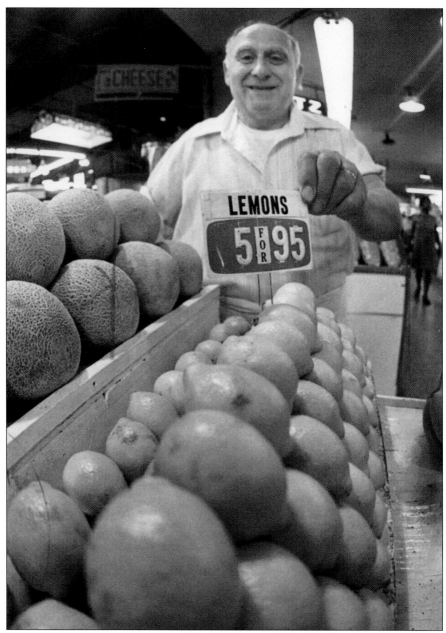

John Liberto may be smiling in this picture because he can offer his customers slightly lower prices than supermarkets could during the so-called "lemon wars" of 1978. In July, which is peak iced-tea season in Maryland, lemons became very scarce. Many supermarkets ran out completely. And when they were to be had, lemons were very expensive—nearly double the previous summer's price. At five for 95¢, the lemons at Liberto's stall were among the least expensive, nearly 30¢ below supermarket prices. The reason for the hike was a drought followed by unseasonable rains in California, where lemons are grown. Limes, which are grown in Florida, were plentiful, but they were only good for gin and tonics. Marylanders still needed lemons for their iced tea. (Courtesy of *Baltimore News American* Photograph Collection, Special Collections, University of Maryland Libraries.)

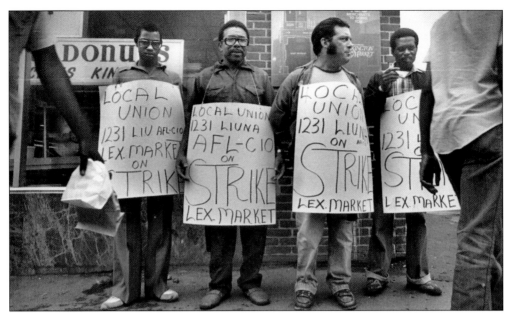

In 1980, some of the market's maintenance workers from the Laborers International Union of North America went on strike over the working conditions. Gloves and work boots were issues, but they also wanted a pay increase from $3.10 to $3.75 over three years. From left to right, the picketers are Ray Harrison, Arthur Owens, Tony Silvestri, and James Latham. (Courtesy of *Baltimore News American* Photograph Collection, Special Collections, University of Maryland Libraries.)

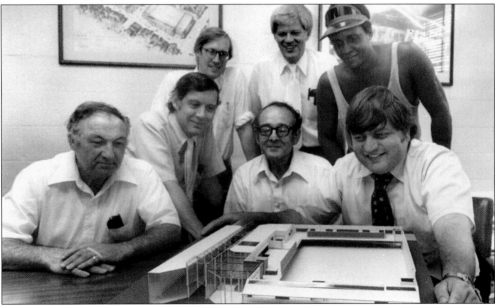

By the late 1970s, the market was ready to grow again. Mark Beck Associates, Inc., designed a light-filled arcade as an extension of the East Market. Shown here is a committee studying the proposed addition. From left to right are the following: (first row) Ted Egorin, Bob Tennebaum, Tony Konstant, and William O. Franz; (second row) Harry McDonough, J. Leonard Lentz, and James Carpenter. (Courtesy of *Baltimore News American* Photograph Collection, Special Collections, University of Maryland Libraries.)

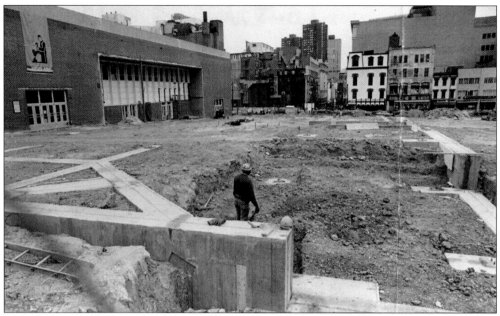

This photograph, looking east across Eutaw Street toward Howard Street, shows the excavation for the addition's foundation. Gone is the old Bachrach building, which subsequently had become the home of Henry Castelberg, the "Diamond King," and then of S.&N. Katz. It was torn down for a subway stop directly across the market. (Courtesy of *Baltimore News American* Photograph Collection, Special Collections, University of Maryland Libraries.)

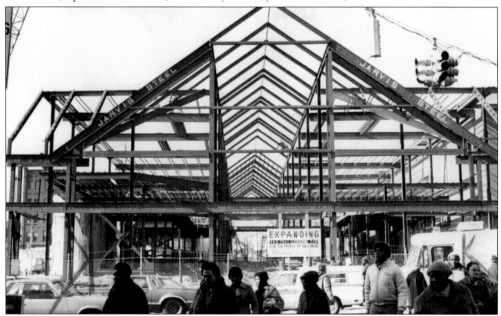

Unlike the market buildings constructed after the fire, which had high windows and stalwart brick walls, the arcade was to be light and airy. Maryland traditions, however, were not forgotten. Tiles representing Maryland products cover the inside pilasters, and signs of Maryland companies that once processed Maryland farm products are around the atrium. (Courtesy of *Baltimore News American* Photograph Collection, Special Collections, University of Maryland Libraries.)

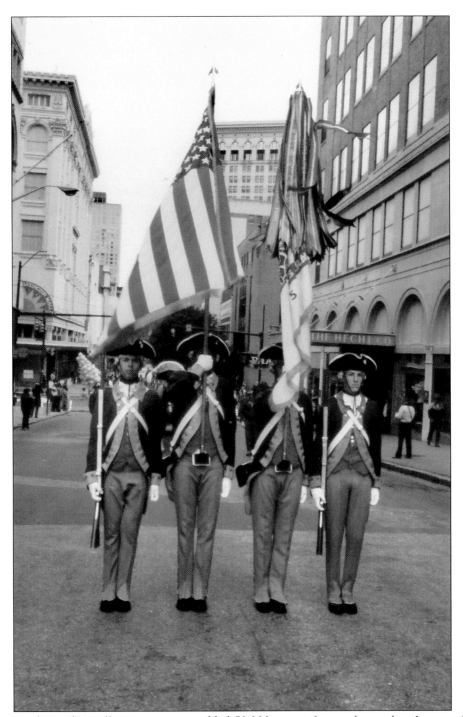

The arcade, an $11-million investment, added 50,000 square feet to the market. It opened in October 1982, to coincide with the 200th anniversary of the market's founding. In acknowledgment of John Eager Howard and his role as a Revolutionary War hero, the parade initiating festivities had a distinctly historical flavor. Here an honor guard marches up Lexington Street toward the market.

Hyman Aaron Pressman, Baltimore's seven-term comptroller, marched up Lexington Street with his characteristic strut. Known as "The Watchdog of Baltimore," for his ferocity in guarding the city's finances, Pressman also was beloved for his spontaneous and sometimes ridiculous limericks.

The parade included seven Conestoga wagons like the ones farmers once used to haul their products to the market. Between the neighing of the horses, the fife and bugle corps, the bagpipes, and the speeches of the politicians, the opening-day ceremonies were a cacophonous affair.

This black-and-white photograph doesn't show the red coats of this unit, which represented the British in the opening-day celebration. They are marching up Lexington Street toward the front of the market and a reenactment of the Battle of Lexington.

Throngs, which had been scarce along the parade route, gathered around the market to see the reenactment. The celebration also included demonstrations by weavers, potters, and blacksmiths, as well as displays of farm equipment and antique cars. (Courtesy of *Baltimore News American* Photograph Collection, Special Collections, University of Maryland Libraries.)

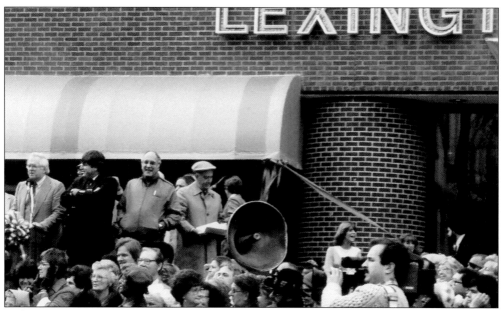

Perhaps the individual who contributed the most to the market's ongoing success was Mayor William Donald Schaefer, shown here wearing a cap and holding papers. Until his administration, Lexington Market operated under a market authority, which reported to the city. When the authority could not meet its bond obligations, Mayor Schaefer brought the market squarely under the city's ownership and rescued it financially. Mayor Schaefer later became governor and comptroller of Maryland.

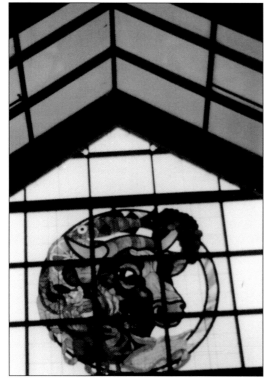

High in the arcade's pediment is a 144-square-foot stained-glass window featuring the head of a bull surrounded by fruits and vegetables, a multi-colored interpretation of the same medallion that had hung over the entrance to the old market before it was destroyed by fire. The window was constructed by volunteers from the Art Glass Alliance of Maryland according to a competition-winning design by Ginnie Neff.

Six

FOUNDED ON FAMILIES

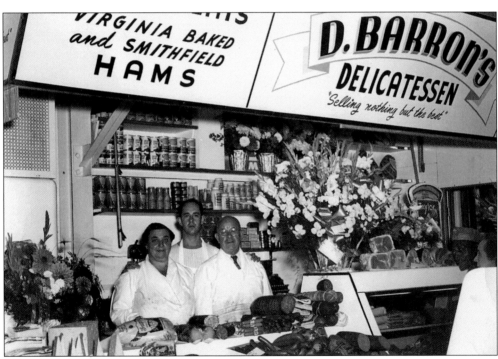

For Lexington Market stall keepers, every sale was personal because their businesses were personal. Stalls were handed down from one generation to the next, and youngsters learned early what it meant to work at the market. Gil Barron, shown here in his family's temporary stall after the fire, stands between his mother, Ida, and his father, Daniel, who founded the family's delicatessen business. Gil Barron graduated from Johns Hopkins University expecting to be a teacher, but the lure of the market was too strong, as he had begun working there as a youngster along with his sister Shirley. Eventually Barron bought his father's stall, and his wife, Carolyn, worked beside him. The third generation of Barrons was next. His two daughters—Laura Lieberman and her husband, Elli, and Ava Shasho and her husband, Harry—worked at the market as did Barron's son, Marc. "Every family at the market had a history," Barron says. (Courtesy of Gil Barron.)

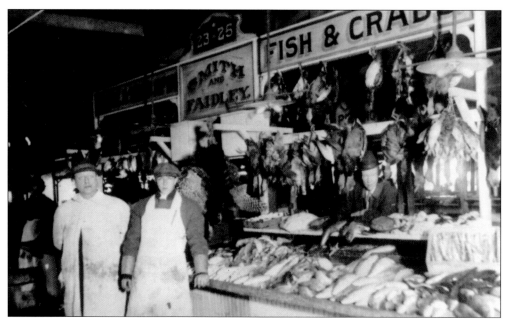

One of the largest and best-known establishments in the market is Faidley's Seafood. John W. Faidley Sr., on the left with his son, John W. Faidley Jr., established the family's business in 1886. From that single stall, Faidley's Seafood has become so well-known that its award-winning fare has been served to four U.S. presidents, and NASA has commissioned it to develop a crab cake for crew members of the space shuttle. (Courtesy of Bill Devine.)

John W. Faidley Jr. and his son-in-law, Bill Devine, oversaw much of the company's expansion. Fellow stall keepers also appreciated Faidley's tireless work ethic and entrepreneurial spirit, and when he died in 1990, he was honored by a special tribute. In a slow procession, his funeral cortege drove up and down Baltimore's downtown streets until they had circled the market. (Courtesy of Bill Devine.)

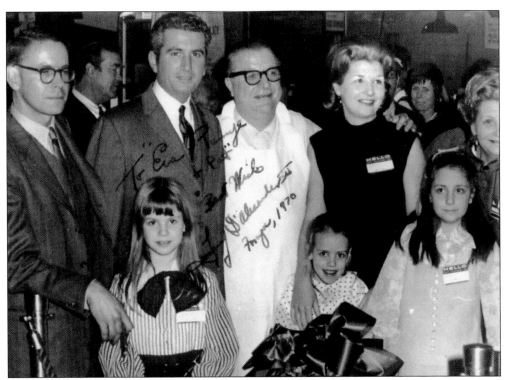

Shown here at the opening of the Faidley raw bar, from left to right, are (second row) Bill Devine; Mayor Thomas D'Alesandro III, whose father had been mayor when the market burnt; John W. Faidley Jr.; Nancy Faidley Devine, daughter of John; and Albina Faidley. Eventually Bill and Nancy Devine became the owners of Faidley's Seafood and their three daughters—Danye (first row, left), Patricia (center), and Eva—all worked there, bringing the family connection to the fourth generation. (Courtesy of Bill Devine.)

Part of the fifth generation of the Faidley family business, 15-year-old Will Hahn, son of Danye and great-great-grandson of John W. Faidley Sr., shucks clams and oysters at the family's raw bar. Today Faidley's Seafood routinely flies its famous crab cakes and crabs to far-flung destinations, but the enterprise remains firmly rooted where it started, in Lexington Market. (Courtesy of Bill Devine.)

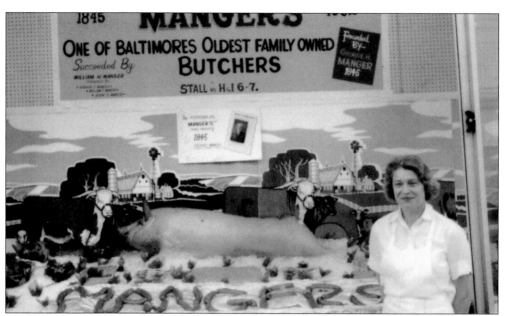

Stemming directly from Baltimore's once extensive meat-packing industry, the Manger family maintained a pork and sausage stall for five generations. Although the family closed their stall in 1980, they still have a Lexington Market presence in the form of the hot dogs they supply Nick Konstant, who is the fourth generation running his family's stall. Notice the name "Manger" spelled out in links.

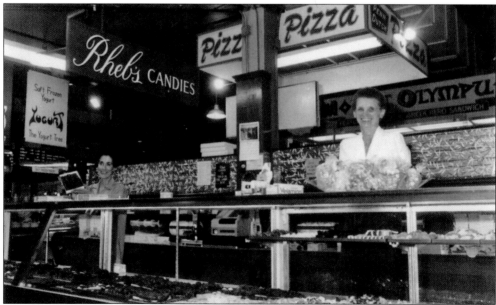

Here Barbara Ellis smiles in the stall for Rheb's chocolates. In 1917, a year after moving into a new house on Wilkens Avenue, Louis J. Rheb founded Rheb's Candies when he and his wife, Esther, began making candy in the basement of their new home. In the 1930s, they purchased a Lexington Market stall, where Rheb's chocolates have been a favorite of Baltimoreans for decades. Now Winn Hargar, grandson of Louis, is teaching his children the trade, making them the market's fourth Rheb generation.

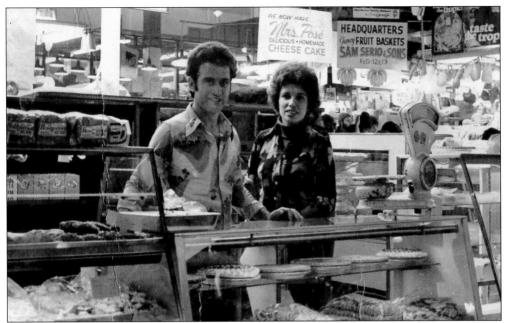

Minas and Fotini Houvardas, natives of Greece, stand in their stall shortly after it opened in 1975. More than 30 years later, the husband-and-wife team still sell Berger Cookie products in their stall. The market has always been a platform for immigrants and their families to gain a foothold into the American enterprise system. Sophia and Foula, the daughters of Minas and Fotini, also worked at the stall. (Courtesy of Minas Houvardas.)

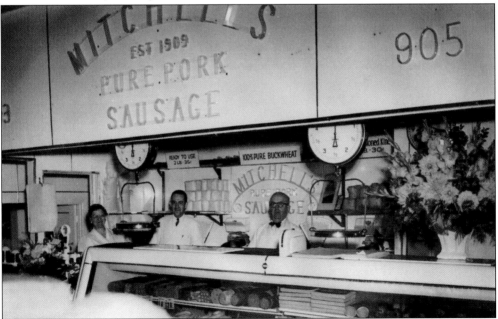

Sometimes the meaning of "family" extends to employees. Here, Edna Whittle, known as the "sausage queen," stands beside Ward Mitchell (center) and his father, Frank W. Mitchell, owner of the stall. When she retired in 1958, Whittle had worked for Mitchell's for 34 years, and many customers assumed she was the stall's owner. (Courtesy of Janet Whittle Freedman.)

Mike Papantonakis stands in the same stall devoted to Utz Potato Chips that his father, Nickolas Michael, a native of Greece, established 1970. Papantonakis, who at 14 started working as soon as the stall opened, bought the business from his parents in 1980. (Courtesy of Mike Papantonakis.)

Hard workers and loyal employees are appreciated. Mike Papantonakis gives a hug to Sharon Heberle, who has worked for him for nearly three years. (Courtesy of Mike Papantonakis.)

Sharon Heberle passes the hug along to her mom, who is also named Sharon Heberle and who also works for Mike Papantonakis, although not full time. (Courtesy of Mike Papantonakis.)

Here Nick Konstant, the fourth generation in his family to be a stall keeper, prepares a chocolate-covered apple for the market's annual chocolate festival. The Konstant stall continues to feature peanut brittle and taffy, which Konstant makes according to his great-grandfather's recipes.

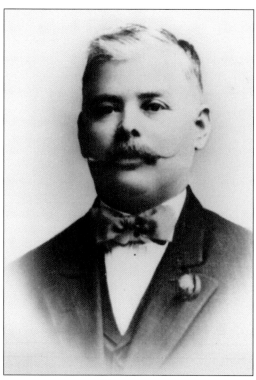

The first Konstant to have a stall was Nick's great-grandfather, Anthony D. Konstant, pictured above. The next was Nicholas A., followed by his son, Anthony N., and son-in-law, Constantine Spero. Until the fire, in addition to their stall, the Konstant family had a confectionary store on Eutaw Street, which they had to sell in order to cover losses at the market. (Courtesy of Nick Konstant.)

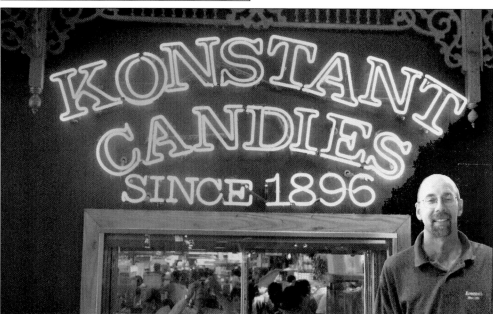

Nick Konstant, beside the sign celebrating his family's longevity at the market, began working at the market while he was in high school, and as a student at the University of Delaware, he came home on weekends to man the stall and to do the payroll for his family's employees. He began working at the family's stall full time as soon as he graduated in 1979. Now he runs three stalls featuring fresh roasted peanuts, candies—including Maryland rock candy—and chili dogs. (Courtesy of Anand Bhandari and the Westside Renaissance.)

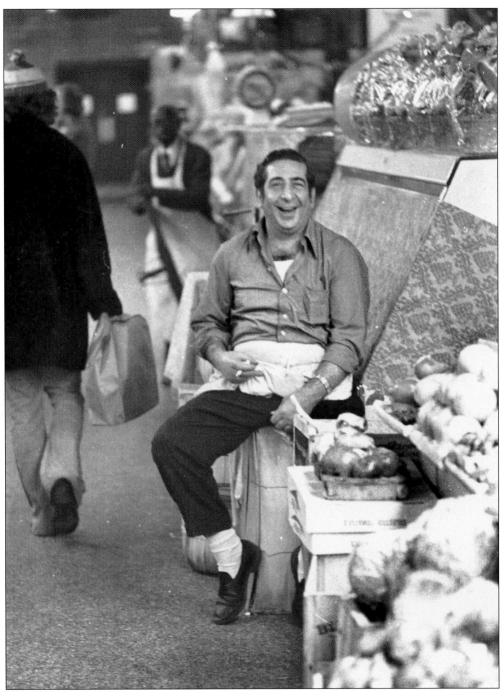

This picture of Anthony Serio relaxing at the end of the day shows the famous Serio fruit baskets aligned on top of the counter. The artistic baskets were a specialty of the family's well-known produce stall, which also featured exotic jellies and nuts from around the world. Four generations of Serios worked at the stall, which was owned by Anthony's uncle, Joseph, one of six brothers. Over the course of the years, all the Serio brothers worked at the market. "All the brothers got together," Anthony recalls. "They all did their share." (Courtesy of Jack Eisenberg.)

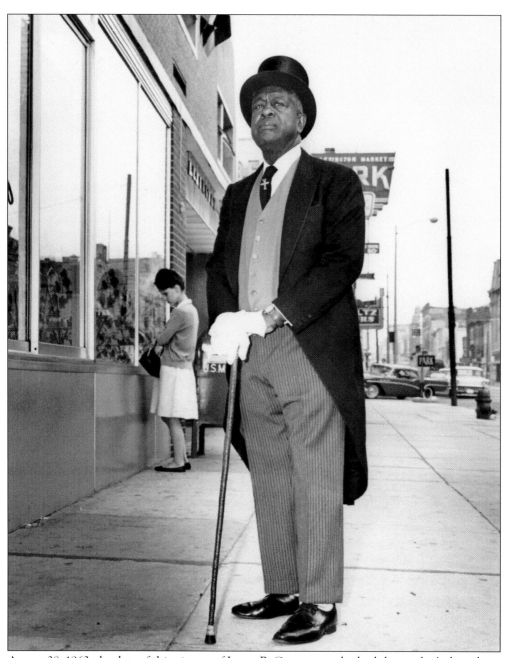

August 28, 1963, the date of this picture of James B. Carpenter, who had the market's shoe-shine concession, is a significant one in the nation's history. August 28, 1963, was the day Dr. Martin Luther King led the historic civil rights march on Washington, where he gave his famous "I Have a Dream" speech. At Carpenter's death, fellow merchants honored him by having his funeral cortege drive past the market in solemn procession, an acknowledgment accorded only those stall keepers who were outstanding examples of the market's enterprising spirit. (Courtesy of *Baltimore News American* Photograph Collection, Special Collections, University of Maryland Libraries.)

Seven

FAMOUS AND FAMISHED

This picture is of a life-size mural of Babe Ruth on the West Market's north wall, behind the stalls. Baltimore native George Herman Ruth was born on February 6, 1895, at 216 Emory Street, about 10 blocks from the market. Shortly thereafter, the family moved even closer, to 426 Camden Street, where Ruth's father owned a tavern. It is not known whether Ruth ever visited the market, but an adventurous boy such as he was would likely have been attracted to the Saturday night gaslights and the bantering hucksters in the old market. Today, whether they are professional athletes or performers at Baltimore's restored Hippodrome Theater, celebrities come to the market, where they stand in line just like everyone else. (Courtesy of Anand Bhandari and the Westside Renaissance.)

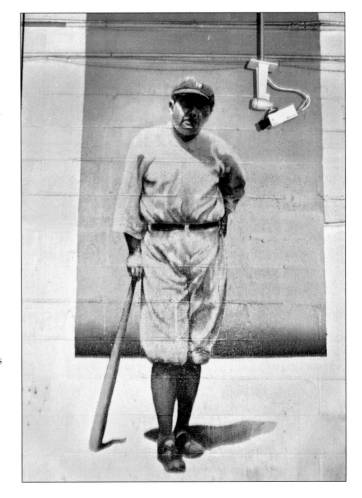

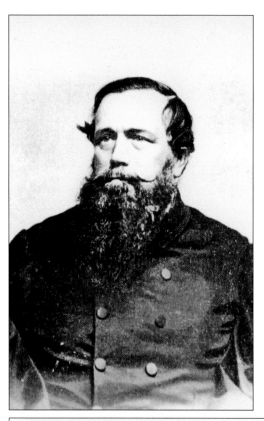

Lexington Market became a popular venue for preachers and politicians. John Wethered, pictured here, served as U.S. congressman from Maryland from 1844 to 1845 as a Whig. In the announcement of nighttime rally, Wethered cautions his supporters to at the *west* end, "as our opponents have called a town meeting for to-night at the *east* end of the market." Confrontation between rival factions could be deadly. On one Election Day in the 1850s, Baltimore's famed Plug Uglies stormed down the market's aisles, firing their pistols and sending customers and stall keepers alike ducking for their lives.

☞ The Whigs of the city are requested to take notice, that the Whig mass meeting to-night, will be held in Lexington market space, at the *West* end, between Green and Pearl streets. As our political opponents have called a town meeting for to-night, at the *East* end of the market, it is suggested to the Whigs of the down-town wards, that in order not to interfere with their arrangements, the better route for them to take in going in procession to the Whig meeting, will be to go up Baltimore street to Green, and up Green street to the place of meeting.

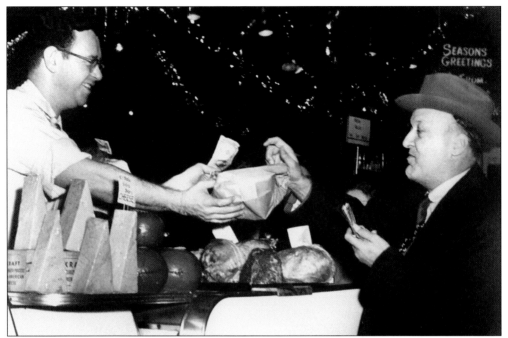

Here Gil Barron hands an order of cheese to Theodore Roosevelt McKeldin, who frequently came to the market while he was governor of Maryland, from 1950 to 1959. McKeldin was so highly regarded as a politician that he had the honor of placing the name of Dwight D. Eisenhower in nomination for president of the United States at the 1952 Republican convention in Chicago. McKeldin also was mayor of Baltimore for two terms. (Courtesy of Gil Barron.)

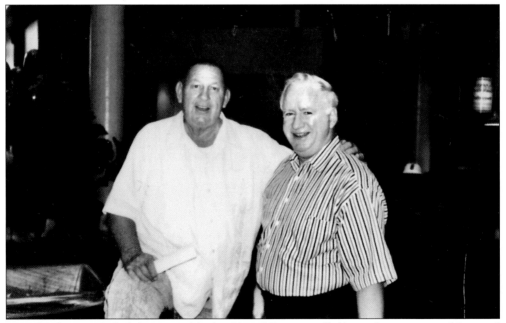

Famed Baltimore Colt defensive tackle Art "Artie" Donovan (left) puts his arm around Leonard Jaslow, former manager of the market. Donovan, who was All-NFL for four straight years and who also played in four straight pro bowls, was elected to the Football Hall of Fame in 1968.

Public figures of national renown, such as Jesse Jackson, pictured here at Faidley's Seafood, frequently are seen at the market. Baltimore's famous medical institutions, professional sports teams, and thriving theaters are all near the market, making it a natural place for anyone famous and famished to visit.

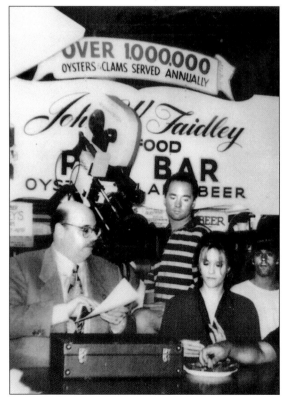

Part of the 1993 smash hit *Sleepless in Seattle* was filmed in Baltimore. Shown here during a scene filmed at Faidley's Seafood is the movie's star, Meg Ryan. Unfortunately the scene was cut from the final version. Other film stars who have come to the market just to shop include John Travolta, Katherine Hepburn, and Carol Channing.

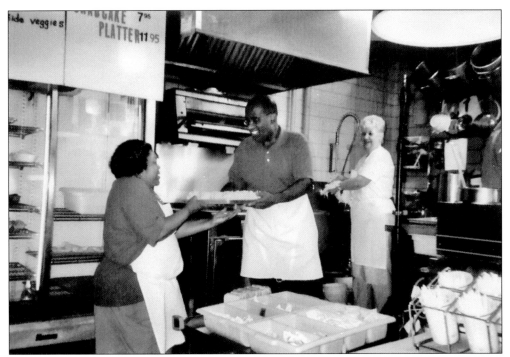

Television producers find the market's no-frills atmosphere makes for an interesting setting, one that's certain to get viewers' attention. NBC's *Today Show* was no exception. In the upper photograph, weatherman Al Roker (center) hands a tray of freshly prepared Faidley crab cakes to longtime Faidley employee Norma Fleming, who will fry them. Nancy Faidley Divine, whose recipe for the crab cakes is a secret, looks on at right. Below, Roker and an unidentified woman are all smiles.

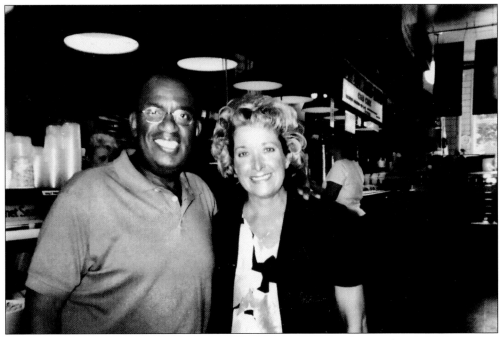

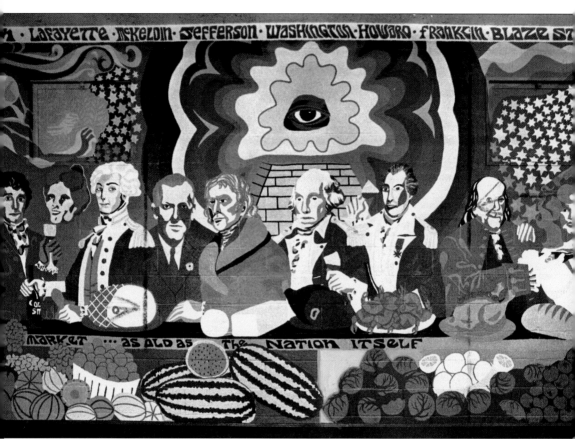

Pictured here is part of a mural by Baltimore artist Bob Hieronimus that covers the length of the upper north wall in the East Market. This segment of the mural pays tribute to national personages who figured in the market's history. On the left is Theodore McKeldin, two-time mayor of Baltimore and two-time governor of Maryland. To McKeldin's right is Thomas Jefferson, who is reputed to have visited the market, and in the center is George Washington, who also is said to have come to the market. To the right of Washington is John Eager Howard, whose generosity initiated the market 225 years ago. And overlooking them all is the "Eye of Providence," an ancient icon that also is on U.S. currency. (Courtesy of *Baltimore News American* Photograph Collection, Special Collections, University of Maryland Libraries.)

Eight

FOOD AND FUN FOR ALL

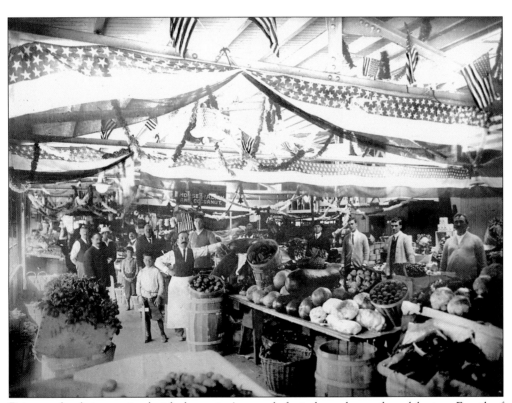

Being so closely intertwined with the nation's struggle for independence, the celebratory Fourth of July decorations and the evident pride of these stall keepers in the old market is understandable. As much as the food, the spectacle of the market always was keen at holidays, whether for the Fourth of July or for some other occasion. Today the market continues the tradition by hosting festivities throughout the year, including a chocolate festival, an annual holiday fashion show, "Lunch with the Elephants" when the circus comes to town, and a crab derby as part of Baltimore's Preakness celebration. (Courtesy of Historic Graphics.com/Ross J. Kelbaugh Collection.)

Every Marylander knows that ham and oysters go together like peanut butter and jelly. When the "R" months come around—months ending in R, for the uninitiated—Chesapeake oysters once again will be at their finest. When and where the practice of coupling ham with oysters began is not known. But as certain as Marylanders want strawberries in May and sweet corn in August, they want ham and oysters in the R months.

Before there was the term "casual dining," there was Lexington Market. Here eaters do not seem to mind a bit that they stand in Faidley's Seafood and eat at plywood tables—the same tables Bill Divine built 30 years ago. Even in the market's arcade, where there are tables with chairs, the concession to comfort is minimum, so eaters keep their focus on their food.

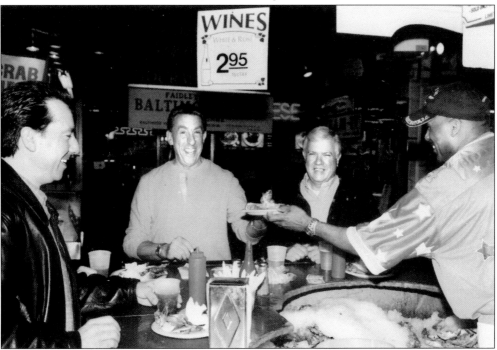

One of the market's most popular events, a standing-room only affair, is the Annual Holiday Fashion Extravaganza presented by Travis Wincey Studios of Baltimore. Wincey, who produces shows throughout the United States and Europe, says that doing the market's show is "special because everyone knows Lexington Market."

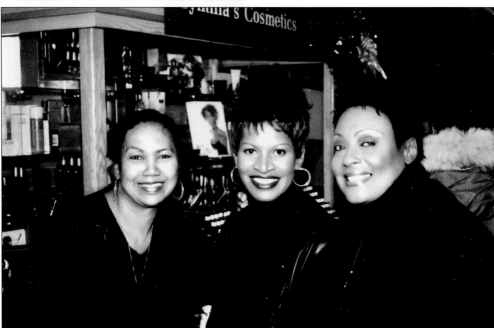

Cynthia McCrory (left), who has a kiosk devoted to Color-Me-Beautiful skin care products and D'Essence perfumes, is one of the few stall keepers permitted to sell products other than food. McCrory, with her friends Marcia Green (center) and Denise MacNeil, helps stage the fashion show. (Courtesy of Ulysses McCrory.)

Up to 25 local and out-of-town models parade designs around the upper level of the arcade, then down the main staircase and onto a runway in the central eating area. Most of the designs Wincey features come from Baltimore boutiques and designers, but he also uses some from New York and elsewhere.

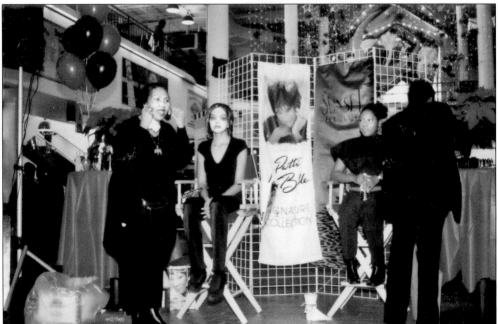

A licensed aesthetician, Cynthia McCrory (left) readies a model for the runway. Her clients include people from all walks of life. McCrory, who gave up a kiosk in a suburban mall to open her business at the market, says she enjoys the market's mix: "I love the difference of people, all creeds, all walks of life. Here, I have it all." (Courtesy of Ulysses McCrory.)

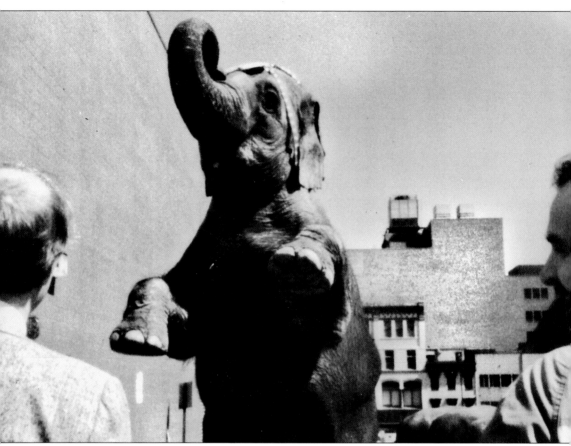

One of the surest signs that spring has come to Baltimore is the annual arrival of Ringling Brothers Barnum and Bailey Circus. For several years, the market and the circus have combined their resources to present "Lunch with the Elephants." Up downtown's narrow streets, the elephant keepers lead their massive charges to the market's parking lot, where crowds of curious children, local celebrities, and heaping tables are waiting. Perhaps in anticipation of the feast, this giant gastronome gets up on his hind legs and gives a whole new meaning to the term "trunk show."

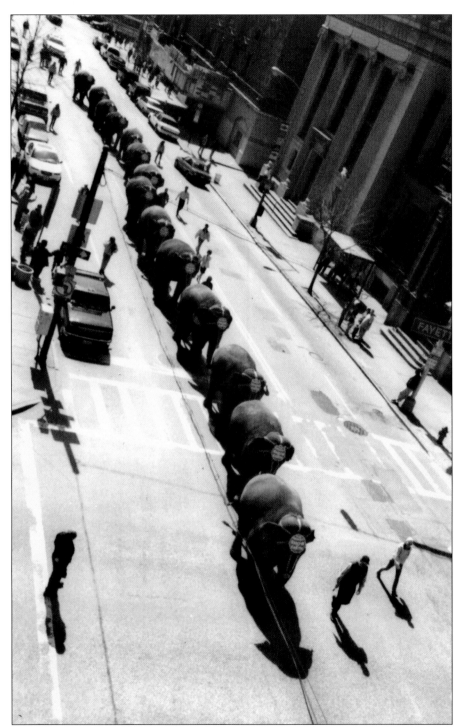

If the old adage is true that "an elephant never forgets," then these pachyderms parading up Eutaw Street know that they are on their way to lunch at Lexington Market. The First Mariner Arena, the site of the circus, is only a few blocks away from the market, where tables piled high with fruits and vegetables are waiting to satisfy giant appetites.

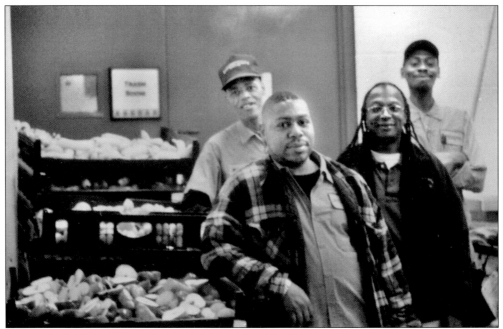

It takes a group of hard workers to feed a herd of elephants. Eight people work nearly two hours to make certain "Lunch with the Elephants" is pachydermically perfect. Some those who prepare the feast, from left to right, are (first row) Marice Owens and Juan Torriento; (second row) William Hayes and Freddie Brown.

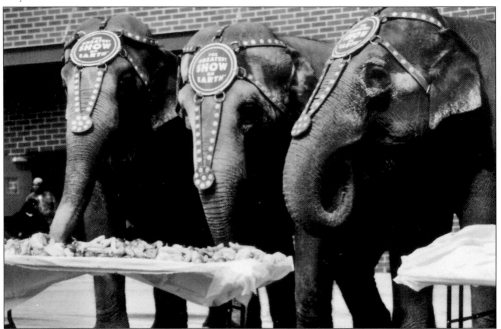

The feast includes 20 loaves of Italian bread, 12 crates of lettuce, 12 crates of Red Delicious apples, 3 crates of Yellow Delicious apples, 10 crates of bananas, 3 crates of loose carrots, 6 cases of blood oranges, and 10 watermelons. At the lunch's end, each elephant uses his left front foot to pick up his melon and smash it on the ground, a stunt that makes its succulent insides easily eatable.

Early in the 1900s, one wag wrote about the "inheritance of joy" a trip to the market afforded him, comparing it to going to the circus: "Second scarcely to the transcendental joy of the annual visit of the circus is to the Baltimore child the weekly joy of a visit to Lexington Market whose paradise of golden apples cost so tiny a sum even a penny affords wonderful possibilities." Little could he ever have imagined that in some future time, Baltimore's children would experience the thrill of the circus and the thrill of the market in combination—transcendent joy times two.

The cheeky sign in the bottom left of this 1970s photograph is typical of the way stall keepers caught the attention of customers. Gil Barron, who owned this stall, and his wife, Carolyn, recalled the intense competition between stall keepers. "Everyone wanted to be the best," Carolyn said. The woman is Midge Farrell and the man with the sideburns is Ken Chard. (Courtesy of Gil Barron.)

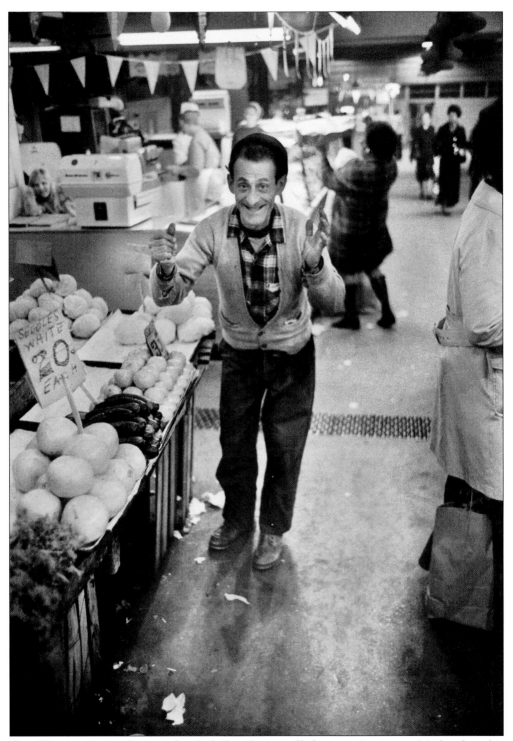

One Christmastime, photographer Jack Eisenberg strolled over to Lexington Market from his home in nearby Seton Hill. The spontaneity and joy of this produce seller in the market's west building captures the holiday spirit and the market's gusto. (Courtesy of Jack Eisenberg.)

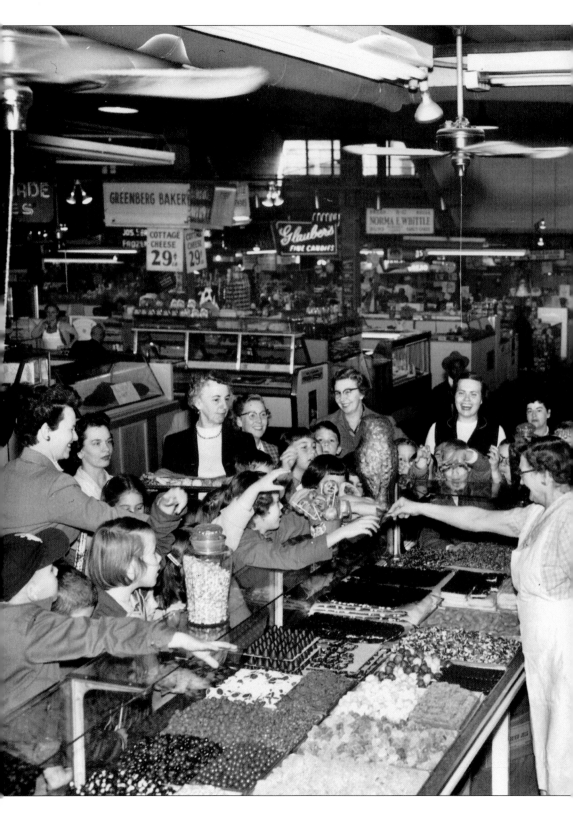

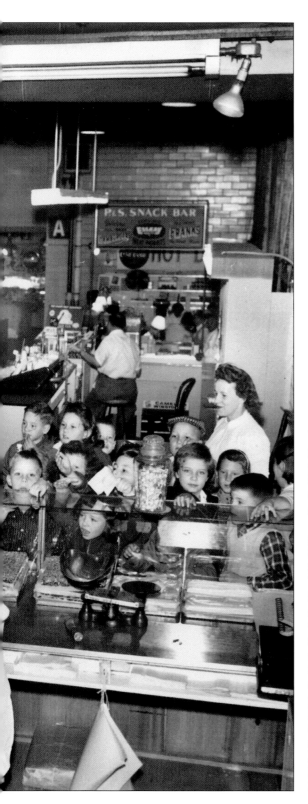

The market's tradition of extending its purpose beyond commercial enterprise is a long one. School groups frequently have found a visit to the market an eye-opening experience. The caption accompanying this photograph from the 1950s reads, "Wide-eyed anxious third graders from Campfield Elementary School stopped at Ortmueller's candy stand on their tour of Lexington Market Tuesday morning for sample goodies from Mrs. Ella Bell who has been in the stand for over 32 years. The children were the first of numerous school groups scheduled to tour the market during the year. Teachers Marian Bankert and Charlotte Porter, with a group of parents, chaperoned the class. Each child was presented with a miniature shopping bag filled with candies, fruits, cookies and peanuts, as a surprise memento of this visit." (Courtesy of *Baltimore News American* Photograph Collection, Special Collections, University of Maryland Libraries.)

The exact date of this photograph is not known, although it may have been taken at Thanksgiving time. Like many major cities, Baltimore holds a Thanksgiving parade to kick off the holiday season, always a busy time at the market.

Perhaps this pig is smiling because this photograph was taken long after 1925, when the market had 118 butcher stalls, many of them devoted to pork products. Or perhaps he is smiling because he is going to ride in the float for the Thanksgiving parade.

The bunch of grapes, the pig, and the straw on the float all hark back to the market's roots and to Maryland's rich agricultural heritage.

Perhaps the theme for this float was the "Three Little Pigs," or perhaps it was for one of the favorite games of small children, "This Little Piggie Went to Market."

UNITED STATES
DOUBLE-CRUST MINCE PIE

 1 recipe Piecrust
 1 qt. Mincemeat

Prepare the piecrust as instructed.
However, instead of pricking the top
crust, press any appropriate Christmas
shape, with a cooky cutter, into the
top crust before putting it over the
mincemeat. Leave the cutouts in place,
put the crust over the mincemeat and
seal the edges. The cutouts will serve
the same purpose as the fork pricks,
but will carry out the Christmas theme.
Bake in a 450° oven 15 minutes, then
reduce heat to 350° and bake another
30 to 35 minutes. Serve with whipped
cream, cheese or Hard Sauce.

In the 1960s, the market published a collection of holiday recipes emphasizing the diversity of its products. It included recipes for sesame cookies from China and for mazurek cookies from Poland. From Germany, there was a recipe for pfefferneuse, or pepper-nut cookies, and from Sweden, one for kottbullar, or Swedish meatballs. There also were recipes for bruccioli, Italian-stuffed roast steak, a French yule log, and English Yorkshire pudding.

Perhaps this turkey is destined to be stuffed with traditional bread stuffing, or possibly, for a more Southern flavor, with cornbread. But it most likely will be stuffed with oyster stuffing, a Maryland favorite, stemming from its Chesapeake roots. Oyster stuffing begins with a pint and a half of shucked oysters and a cup of sweet butter and goes on from there.

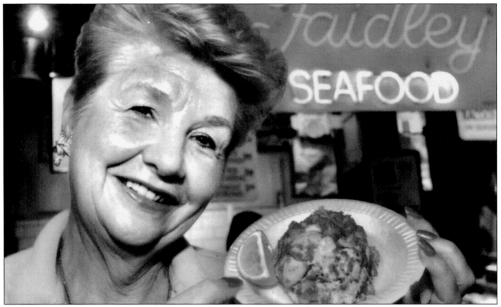

Whether it is an extravagantly oversized crab cake or a five-pound bag of jellybeans, shoppers can satisfy almost any gastronomical craving without an eyebrow being raised about cholesterol or calories. Here Nancy Devine, whose grandfather founded Faidley's Seafood, holds one of her world-famous crab cakes. They come in three variations: front claw, back fin, or jumbo lump. Each is seasoned differently according to a formula only Nancy knows. (Courtesy of Bill Devine.)

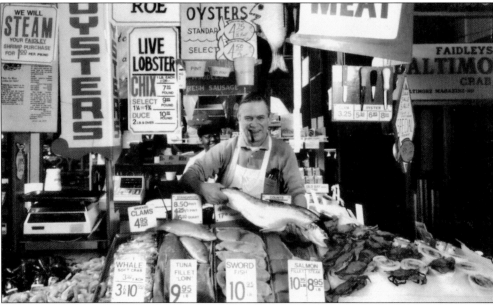

There is nothing apologetic about the market; it is for shoppers whose appetites are not intimidated by big, rich, and sometimes raw foods. Can it be overwhelming? Yes. But once a cook gets his or her bearings and realizes that it is very hard to ruin the flavor of something that is the very best to begin with, shopping at the market can become an adventure. The trick is to take home to your kitchen the brash, confident attitude of the stall keepers. Here Bill Devine tempts a customer with a fish.

This man's enthusiasm is typical of the market's unabashed attitude. Sometimes it is worth the trip just to eavesdrop on conversations. One of the best comments heard lately: "I ate it so fast I didn't have time to know whether I liked it or not."

The bull may be the icon for the market, but the blue crab is the icon for all things Chesapeake. The scientific name for the Atlantic blue crab is *Callinectes sapidus*, Rathbun, *callinectes* being the Greek term for "beautiful swimmer." In his Pulitzer Prize–winning book by that title, William Warner asserts that the Atlantic blue crab is indeed beautiful. Its colorization ranges from deep lapis lazuli to cerulean with flecks of bright orange-red.

Every year, the market, in conjunction with the University of Maryland medical system and Maryland General Hospital, hosts a community health and nutrition day featuring screenings for issues ranging from blood pressure to diabetes. There also are menus designed to promote a healthy diet. On the left, a chef passes out samples, and below, Casper Genco, executive director of the market authority, has his blood pressure taken.

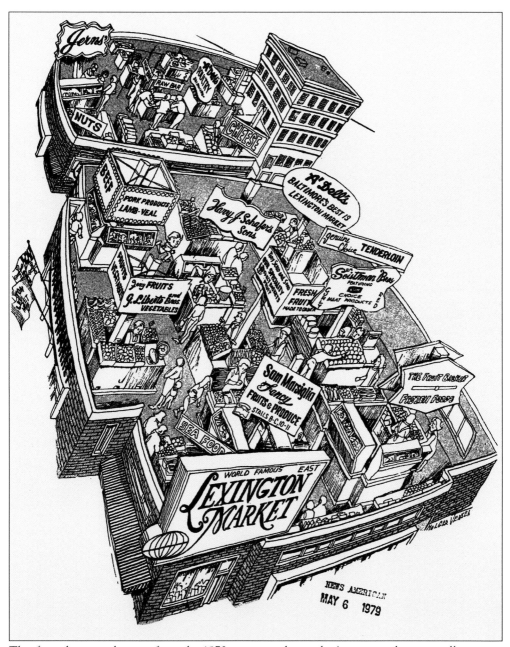

This fun schematic drawing from the 1970s captures the market's spirit, with every stall on every aisle tempting the shopper with hundreds of tasty possibilities. Some of the stalls with old familiar names, such as Liberto produce and Schafer meats, have closed. In other cases, stall keepers who wanted to retire sold their names and recipes to new stall keepers, so that the customer base and product could be maintained.

The market has managed to stay vibrant by adjusting to the times. Long gone are the ladies trailed by chauffeurs who carried baskets laden with provisions. Even housewives coming for their weekly shopping are fewer and fewer. The demand for something fast and cooked, whether for lunch or dinner, has increased. The food has changed, but the smiles stay the same.

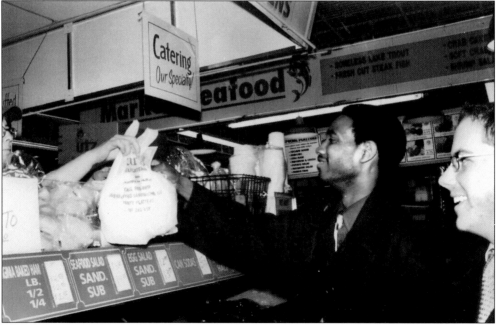

The market is two blocks from the University of Maryland's Baltimore campus, which includes the schools of law and medicine, as well as the principal hospital of the University of Maryland medical system. The market is also close to the financial district, making it busy professionals' perfect choice for lunchtime.

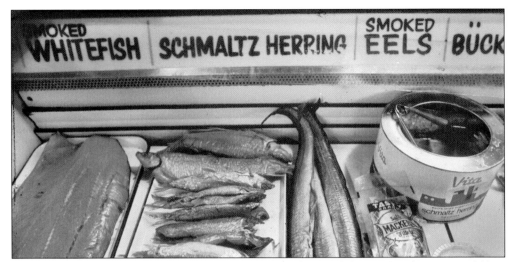

The name "herring" refers to hundreds of varieties of saltwater fish. In 1874, shoppers could buy a dozen at the market for 20¢. Schmaltz herring are high-fat fish that have been filleted and preserved in a brine of course salt and brown sugar. It is used by people wanting to make pickled herring, or it can be cooked once the salt has been soaked out.

Not the least of the market's attractions are its baked goods, especially its unusual cookies—some Korean, some German, some Greek—and all good.

Going to the market is a holiday tradition for some families, who feel the season is not complete without a box of Rheb's truffles or a quart of Mary Mervis shrimp salad. In 1971, Kurt Schultheis (right) got to sit on one of Santa's knees, while his friend Jay Payne, who suffered from spina bifida, got to sit on the other. (Courtesy of William Schultheis.)

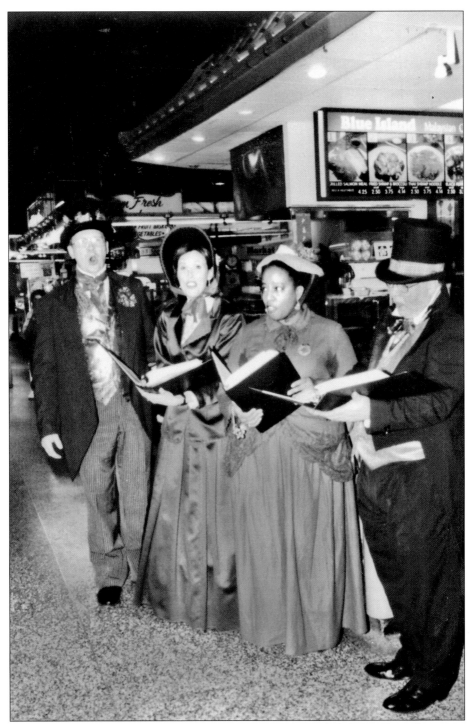

Doubtless, at some point in their concert, these carolers serenaded the market's shoppers with that favorite old German carol, "O Tannenbaum." Along with New Jersey, Michigan, and Iowa, Maryland appropriated the carol's melody for its state song. The first verse of "Maryland, My Maryland," acknowledges the heroic deeds of John Eager Howard, the founder of the market.

In this tongue-in-cheek drawing of a dog looking longingly at a meat counter, artist Ruth Bear Levy continues the tradition of Aaron Sopher, another Baltimore artist who found the market, with its colorful mix of people and products, inspirational. ("Lexington Market" painting by Ruth Bear Levy; photograph courtesy of the Jewish Museum of Maryland, 1999.012.013.)

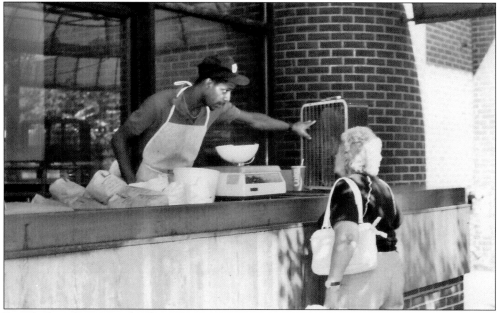

Even before they open the door, the market entices visitors with the delicious aroma of fresh roasted peanuts. A newsletter from 50 years ago reads, "Nobody can remember when there was not a peanut stand just outside the Eutaw Street entrance." Half a century later, that observation still holds true.

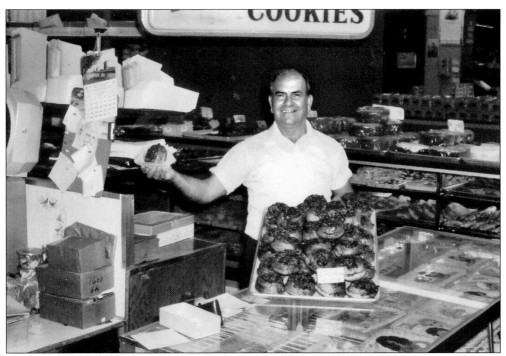

Who could resist baseball-size sticky buns? The alchemy of yeast, flour, cinnamon, pecan, melted brown sugar, honey, eggs, vanilla, and raisins is more than any mere mortal can withstand.

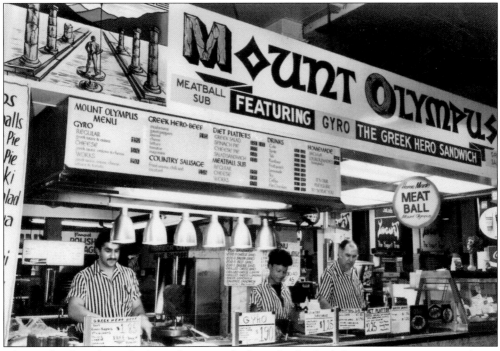

The market has always had a wide array of ethnic food, which became mainstream within a generation. The Greek warrior staring back at the home of the gods is an interesting touch on the sign, as is the other sign advertising a cheese pie "diet" platter.

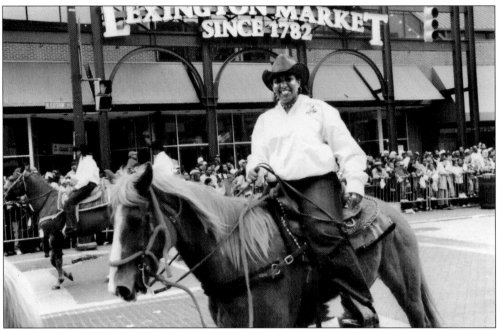

Baltimore's famous Pimlico Race Course is the home of the prestigious Preakness Stakes, which, with the Kentucky Derby and Belmont Stakes, makes up horse racing's "Triple Crown." The Saturday before the race, a two-hour parade kicks off a weeklong celebration. The market has a float, and as one of the parade's sponsors, it plays a central role in promoting the event.

The market's own version of the Preakness is its annual crab derby, here hosted by local TV personality John "Kinderman" Taylor. Local celebrities get to be "jockeys" for a day and coax their crabs to the finish line. The person whose crab is the winner has a donation made to their favorite charity, and their crab is released back into the bay. Losing crabs, well, they're not so lucky.

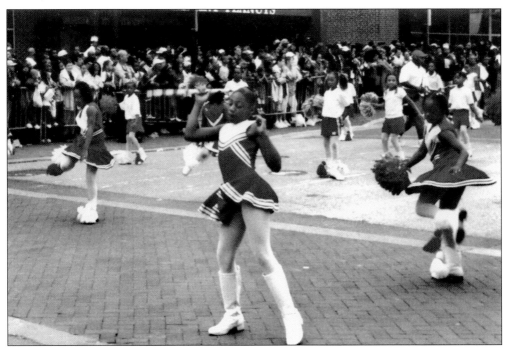

The Preakness parade features 70 units, including Baltimore's traditional mounted police, giant helium balloon characters, marching bands, beauty queens, giant puppets, floats, the U.S. Navy drill team, and Percherons, which are huge horses rivaling Clydesdales in size. It also features these high-stepping baton twirlers.

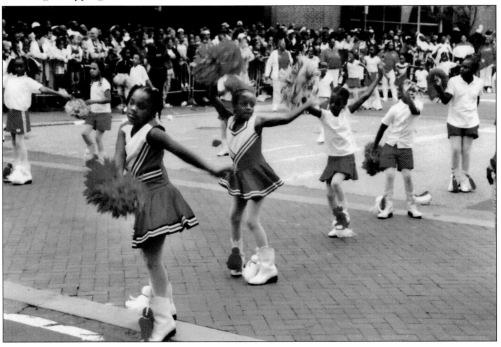

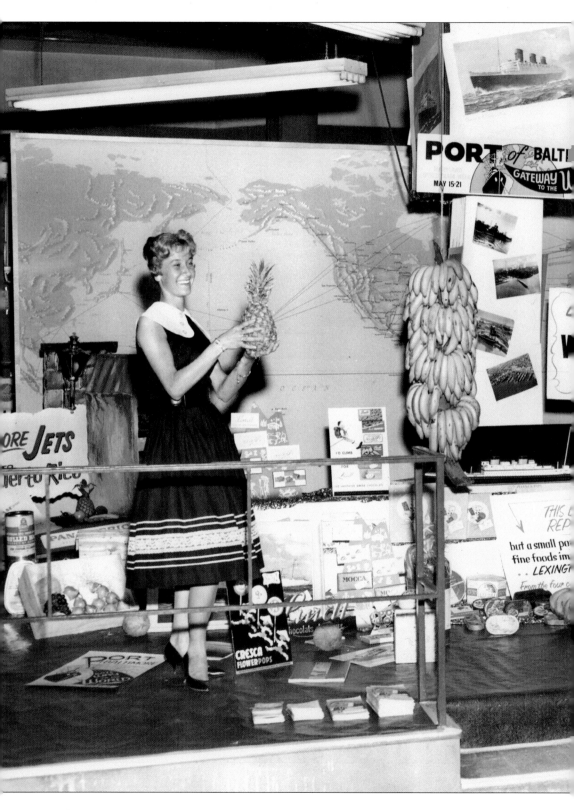

The lifeblood of Baltimore runs through its massive commercial harbor. In 1960, the port celebrated world-trade week, which included harbor tours, a whale-boat race, and a race at Pimlico Race Course to honor ship captains. The market featured a display of foods from around the world that were available at its stalls. In this picture, Margie Hepner, holds up a pineapple, the traditional symbol of hospitality. To her right is Thomas McDermott, assistant general manager of the Lexington Market Authority in 1960.

Every October, the market hosts a chocolate festival in its arcade. The festival is an opportunity for the market's merchants, as well as for outside vendors, to show off their skills with everything chocolate. Shoppers can watch strawberries, pineapples, apples, and many other kinds of fruit being dipped into rich brown molten chocolate, or they can indulge themselves with chocolate cakes, cookies, or brownies.

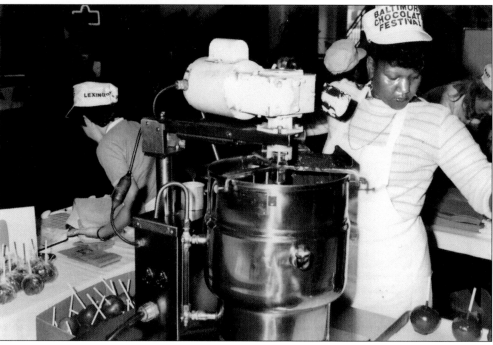

This little girl obviously was determined to taste every spec of chocolate available, even those that might have lingered on her lips. To the amusement of the woman at her right, she unabashedly uses her tongue to lick away every last morsel. Over three days, more than 30,000 people visit the festival, which has become one of the market's most popular annual events.

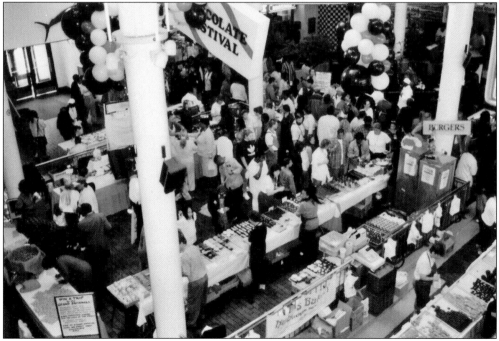

This abundant display of Brazil nuts almost begs a cook to get out a recipe for fruitcake or pork chops coated with corn meal and nuts. For the casual stroller, the market presents a veritable feast for the senses. It is an opportunity to see food's subtle colorization and textures and to experience olfactory delights—the briny scent of fish or the subtle aroma of these nuts from the Amazon.

Baltimore has a long tradition of candy makers, possibly because it is the home of a sugar refinery. As a consequence, the city has a sizeable sweet tooth that it satisfies at the market. Nick Konstant says he sells several thousand pounds of jellybeans every year at his stalls. Flavors include cotton candy, bubble gum, blueberry, coconut, strawberry, and licorice.

These cookies might want to masquerade as "creme puffs," but every Baltimorean will recognize them as Bergers, the vanilla cookie with a mound of perfect chocolate on top. Founded in Baltimore in 1835, Berger Bakery has passed through three families, but the satisfaction its cookies give continues, as does its tradition at Lexington Market. Berger cookies can be bought at the stall of Minas and Fotini Houvardas.

The market currently has a dozen delicatessen stalls, each selling its own cheese, salads, pickles, and processed meats, such as this ham. Some stall keepers, in the cooking area under the East Market, prepare their corned beef according to time-honored family recipes.

Part of the market's ongoing commitment to good food and good times was this presentation by Baltimore's Yum-Yum Sisters. For several weeks, the duo gave cooking demonstrations in the market's arcade, and onlookers got to taste the final product.

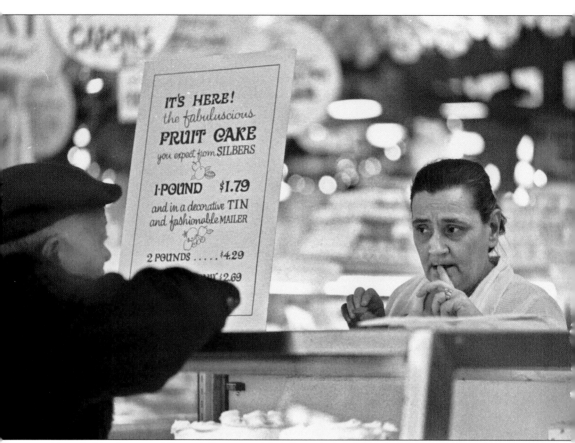

Founded by Isaac and Dora Silber in 1905, Silber's bakery grew until it eventually supplied 50 retail outlets and maintained a stall at Lexington Market. Silber's was especially famous for its rye bread, which used sourdough, instead of yeast, as a starter. While Silber's produced hundreds of products, its peach cake was especially memorable. Silber's closed in 1980, although Silber tins, such as the one advertised on the sign, are now collector's items on eBay.

Long before they become household names, every famous person was famous in their own household. Perhaps these children in the chorus of Baltimore's Garett Heights Elementary School will have their pictures hung among those famous people who have visited the market. For a dozen years, the chorus of third-, fourth-, and fifth-graders has been performing at the market under the direction of Marcia Sellers. Twice yearly, at Christmas and in the spring, 50 to 70 children perform programs that include works from Broadway, jazz, and classical composers.

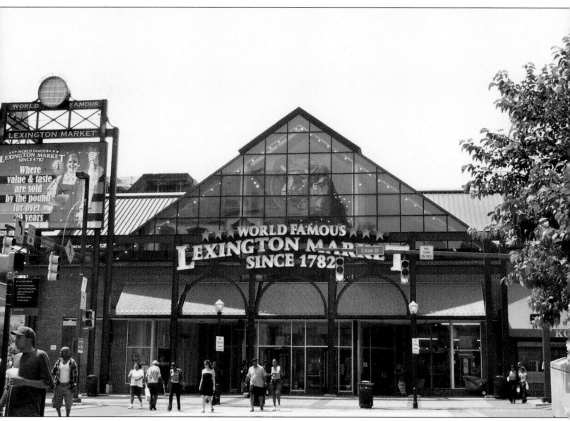

Every day, between 15,000 and 18,000 people visit the market, making a total of 3.7 million visitors a year, which is more than the combined attendance at the nearby baseball and football stadiums. The market currently encompasses 192,269 square feet and has 180 stalls.

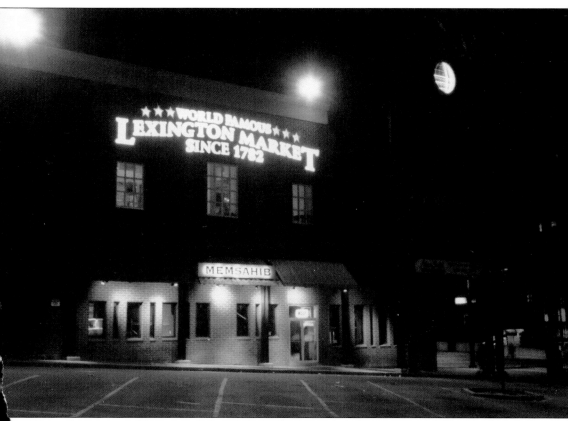

The market opens at 6:30 a.m. and closes 12 hours later. But these hours are misleading: long before their first customer arrives, stall keepers are getting ready for the early morning rush of workers wanting coffee and pastries, or those just getting off the night shift at the nearby University of Maryland Hospital. And at night, delivery trucks arrive with products from around the world. For more than two centuries, Lexington Market has adjusted its procedures and rhythms to changing demands, but the market, and its spirit and place in the heart of Baltimore, have remained constant—which is something to celebrate.

DISCOVER THOUSANDS OF LOCAL HISTORY BOOKS
FEATURING MILLIONS OF VINTAGE IMAGES

Arcadia Publishing, the leading local history publisher in the United States, is committed to making history accessible and meaningful through publishing books that celebrate and preserve the heritage of America's people and places.

Find more books like this at
www.arcadiapublishing.com

Search for your hometown history, your old stomping grounds, and even your favorite sports team.